IMAGES OF AMERICA

CENTRAL OF GEORGIA
RAILWAY

IMAGES OF AMERICA

CENTRAL OF GEORGIA
RAILWAY

JACKSON McQUIGG, TAMMY GALLOWAY,
AND SCOTT McINTOSH
FOR THE ATLANTA HISTORY CENTER

ARCADIA

Atlanta History Center
130 West Paces Ferry Road, N.W.
Atlanta Georgia 30305-1366
(404) 814-4085
www.atlhist.org

First published 1998
Reissued 2003

Published by Arcadia Publishing
an imprint of Tempus Publishing
Charleston SC, Chicago, Portsmouth NH,
San Francisco

Printed in Great Britain

Library of Congress Catalog Card: 2003116336

For all general information contact Arcadia Publishing at:
Telephone 843-853-2070
Fax 843-853-0044
E-mail sales@arcadiapublishing.com

For customer service and orders:
Toll Free 1-888-313-2665

Visit us on the Internet at http://www.arcadiapublishing.com

Contents

Introduction

The Central of Georgia Railway was in its twilight when the *Nancy Hanks II* made its last run from Atlanta to Savannah on Friday, April 30, 1971. The railroad that traced its roots and proud heritage to the Central Rail Road & Canal Company—which was organized in 1833 by a group of Savannah businessmen to support their city's port—had been acquired eight years before in 1963 by the much larger Southern Railway. By 1971, the Central of Georgia was well on its way to losing its identity and shared much of its executive management with the bigger railroad.

Those who knew Savannah surely saw irony in the passage of the *Nancy Hanks II* and the Central's marriage into the Southern Railway System. Southern could trace its heritage back to the South Carolina Canal & Rail Road of 1827, and the success of "Charleston's Railroad" helped to fuel the competitive fires that have always burned between Savannah and Charleston. It was the South Carolina Rail Road which had so alarmed Savannah leaders in the first third of the 19th century. Because of the South Carolina Rail Road's inland reach, Savannah's seaport lost much of its export traffic of cotton, lumber, naval stores, and other agricultural products to the wharves of Charleston. Construction of the Central, the city reasoned, would help Savannah retain its position as a major ocean port on the East Coast, just as it had been since well before the American Revolution. After all, it had been the S.S. *Savannah* which set out for Liverpool from her namesake city on May 22, 1819, becoming the first steamer to cross the Atlantic Ocean in the process.

Despite its late start when compared to the South Carolina Rail Road, the Central was a pioneer in its own right. It would be the first railroad in the state of Georgia when Irish workers began to construct the line in December 1835, and hopes for the new line were extremely high. Yet right from the start, the Central was woefully undercapitalized. For most of the years leading up to its merger with Southern Railway 128 years later, in fact, the railroad would find itself in a state of fiscal turmoil.

By 1837, the Irish track gangs had been replaced by African-American slave laborers. Change was in store for the company's name, as well; it was now known as the Central Rail Road & Banking Company of Georgia. This change in identity reflected that the company had gained banking privileges from the state, thanks to a modification of the railroad's charter by the Georgia Legislature, allowing the railroad to obtain badly needed capital dollars. Still, construction inland from the lowcountry was slow going; it took six years to complete 160 miles of track, well under 2 miles of track a month. The line finally reached the Ocmulgee River opposite Macon in October 1843.

During the 1850s the Central Rail Road began to expand. In 1850, the company organized its own steamship line, the American Atlantic Screw Steamship Company, to run a Savannah-to-New York route. A bridge into the town of Macon was constructed in 1851, giving the Central a direct connection with the Macon & Western Railroad, and subsequently Atlanta and her railroads. The Central enjoyed a period of brief prosperity during this decade, and stockholders benefitted from 5 to 15 percent returns on their investments throughout the decade. But the good times wouldn't last.

The Civil War lay just ahead, and it would hammer the Central Rail Road & Banking Company. While the first three years of conflict were actually beneficial to the rail line, the blockade of Southern ports claimed Central's steamship line as a casualty. Sherman's "March to the Sea" in November 1864 would ultimately undo the remainder of the railroad's wartime success. Trains wouldn't again run between Savannah and Macon until June 1866.

By 1872, with a slightly modified name, the Central Railroad & Banking Company was in expansion mode again. Another Savannah-New York steamship line was acquired and a number of railroads—including the Macon & Western—were purchased in the 1870s and 1880s. In 1875, the Central jointly acquired what would become the Western Railway of Alabama with the Georgia Railroad & Banking Company. In 1881, it would acquire one-half interest in the railroad assets of the Georgia Railroad & Banking Company, an investment it would maintain until the Central experienced more monetary troubles in 1892.

Bought twice and sold once since the Civil War ended, the Central had by 1888 come under the control of the (Richmond) Terminal Company, a conglomeration of Southeastern lines. The Terminal Company soon ran into monetary troubles, and was ultimately rescued by financier J.P. Morgan, who acquired the near-bankrupt Terminal Company and built the Southern Railway from its ashes in 1894.

The Central defaulted on certain corporate bonds on July 1, 1892, an act which plunged the line into a tempestuous receivership. A little over three years later, on October 7, 1895, the Central was sold at public auction for $2 million to a reorganization committee which included Southern Railway and other Central creditors. In a complex restructuring, the Central Railroad was reorganized as the Central of Georgia Railway on November 1, 1895. Initial public concerns about this arrangement soon wore off: "All rumors with regard to the Southern's controlling the Central in a manner to improperly increase its own business have subsided," *The Atlanta Constitution* noted on October 8.

Southern Railway's partial control of the Central of Georgia would last until 1907, when the Central was sold by the reorganization committee to Edward H. Harriman, who also controlled the Union Pacific, Southern Pacific, and Illinois Central railroads. Harriman transferred ownership of the Central of Georgia to the Illinois Central in 1909. During the 1920s, the Central of Georgia's route structure grew to reach far from its original Savannah-Macon line. The Central had come to serve cities far from the Georgia coast, including Athens and Augusta in Georgia; Montgomery and Birmingham in Alabama; and Chattanooga in Tennessee. Passenger service included trains all along these routes, including trains 101 through 110, which provided suburban commuter service in the Atlanta area from the towns of East Point, Hapeville, Forest Park, and Jonesboro into the city. It also included Central participation in through trains such as the Chicago-to-Florida *Seminole*, which debuted in 1909.

While the nation was in the throes of World War I, on January 1, 1918, the federal government— under the auspices of the United States Railroad Administration (USRA)— took over the nation's major railroads. All lines of any size or strategic importance, including the Central of Georgia, were leased by the USRA with the idea of facilitating better coordination between the various railroads in order to support the war effort, with W.G. McAdoo in charge as director-general of the USRA. While the nationalization experiment produced mixed results, there is no disputing the fact that USRA-controlled lines moved 8,714,582 troops in total before the lines were returned to private operation on February 29, 1920.

Illinois Central retained ownership of the line until December 19, 1932, when the Central of Georgia again entered receivership after it defaulted on Reconstruction Finance Corporation-provided loans. An early casualty of the railroad's money woes was the railroad's passenger service to the Savannah enclave of Tybee Island, which was discontinued in 1933 (the right-of-way from Savannah to Tybee Island, long since abandoned, is today a rails-to-trails recreation path). Divestiture would be the theme for the Central of Georgia during the WW II years; it began with the Central's corporate parent. In 1942, the Illinois Central wrote off its $19,998,500 investment in the railroad. Two years later, in 1944, the Central sold its 50 percent interest in the Western Railway of Alabama to the Georgia Railroad. The upshot of all of these changes, when added to booming wartime traffic, would be a healthy balance sheet for the Central of Georgia. It exited receivership in 1948.

Passenger service thrived during the postwar years. Trains always carried large quantities of mail and express, from the Midwest to Florida. In 1947, two streamliners named after racehorses—the *Man O'*

War and the *Nancy Hanks II* (the II designation distinguished it from a short-lived 19th-century predecessor) were introduced to provide service on the Central of Georgia between Atlanta and Columbus, and Atlanta and Savannah, respectively. They were well received; the *Nancy* carried 14,108 passengers during its first month of operation alone.

Further broadening its horizons, the Central made another important acquisition in 1951. The Savannah & Atlanta Railway (S&A) was acquired by the Central of Georgia for $3,500,000. The S&A operated between Savannah and Camak, Georgia, where it maintained a junction with the Georgia Railroad. The Central's purchase of the S&A not only gave it access to additional port facilities near Savannah, but also allowed it to eliminate one of its major competitors within Georgia. The St. Louis-San Francisco Railway (known more familiarly as the "Frisco Lines") began to purchase shares of the independent Central of Georgia during the 1950s. By 1956, it had acquired a controlling interest in the Central (71 percent), a relationship it maintained for seven years. However, in 1963, the Interstate Commerce Commission, charging that the Frisco's control of the Central was bad for competition, ordered the St. Louis–San Francisco to liquidate its holdings in the smaller railroad.

Enter Southern Railway. In June 1963, Southern would acquire the Frisco's stock holdings in the Central of Georgia for $22,655,000. Southern then acquired the remaining shares of the Central at the same price per share, resulting in a total purchase price of $32,700,000 paid by Southern—a bargain for a railroad valued by some at $126 million. In the transaction, Southern acquired 1,950 miles of track, 146 diesel-electric locomotives, 9,439 freight cars, and 98 passenger cars. When the federal government gave the nation's private railroads the option of exiting the passenger train business by creating Amtrak on May 1, 1971, Southern Railway-owned Central of Georgia elected to join the quasi-governmental passenger train company. Amtrak thus was afforded the decision whether or not to continue the *Nancy*—which was by then the Central's last surviving passenger train—and decided not to, signaling the beginning of a closing act in the story of passenger trains in Georgia.

In the grand scheme of things, the loss of the *Nancy* was decried by a relative few. The public's enthusiasm for train travel had waned through the years and the Central had gradually become apathetic about providing passenger service. What had become the reality was aptly captured by *Atlanta Constitution* newspaperman Gene Tharpe in an April 25, 1971 article. After riding the train, he wrote: "As the few passengers left, only a small number of them looked back at the *Nancy Hanks*. They were mostly the ones who had ridden the *Nancy* one more time because they knew—and understood—that a great part of the Georgia and America that used to be will die on Friday. Most of the passengers only got in their cars and drove away."

Despite a lawsuit filed by the National Association of Railroad Passengers seeking a court order to keep the train running, the *Nancy Hanks II* passed into oblivion on schedule—April 30, 1971. The Central itself was right behind. On July 1, 1971, Southern re-styled the Central of Georgia Railway into a more tightly held subsidiary known as the Central of Georgia Railroad; distinct locomotive and freight car paint schemes and independent management soon fell by the wayside as the Central of Georgia was brought ever closer to its corporate parent. By 1982, the Central and its properties would be little more than a relatively obscure accounting entry in the books of Norfolk Southern Corporation, a mammoth transportation company.

In this volume, though, the bygone era of the Central of Georgia is still very much alive. The vast majority of the photos on these pages are from the Atlanta History Center's Norfolk Southern Collection, placed at the Center by Norfolk Southern in 1997. With a few notable exceptions, most are from the late 1940s and 1950s, and most appeared in the pages of the railroad's company publication, the *Central of Georgia Magazine* (later called *The Right Way* magazine). It is hoped that these pictures will bring back memories for some and spur the imaginations of still others who were never afforded a trip on the *Nancy* or the *Man O' War*.

So join us—won't you?—as the trains of the Central roll again.

Highball

Passenger Service on the Central of Georgia Railway

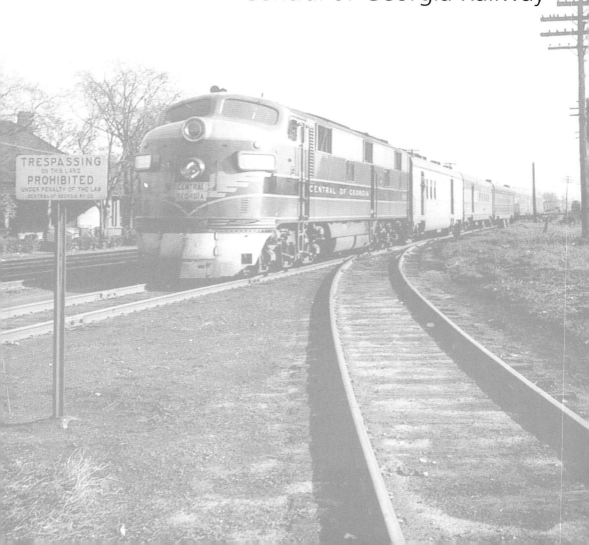

Passenger service on the Central of Georgia Railway in the postwar years of the 1940s and 1950s was significant. Although the C of G operated interstate passenger trains such as the Seminole and the City of Miami jointly with other railroads, it was really two newly inaugurated intrastate trains—the Atlanta-Savannah Nancy Hanks II and the Atlanta-Columbus Man O' War—that defined this service. New streamlined cars ordered from American Car & Foundry and the Budd Company represented a bold and tremendous vote of confidence in the future of passenger trains on the part of the railroad's management.

This optimism showed up in the Central of Georgia Magazine (later called The Right Way magazine). Its pages were filled with passenger department celebrations of all kinds. On-board fashion and flower shows, happy children on school field trips, and smiling crews eager to serve Central travelers were the subjects of more than a few photos. Even Callaway Gardens, the publication delighted in pointing out, had its own miniature version of a C of G passenger train.

But as the increasing roar of the automobile and the jetliner became more apparent, so too did the obvious: the party wasn't going to last.

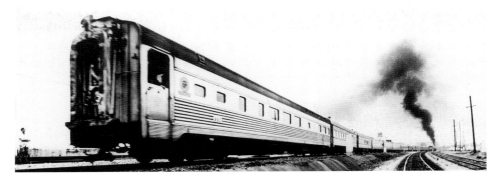

The *Nancy Hanks II* heads east to Savannah on her last run, Friday, April 30, 1971. Between Atlanta and Jonesboro, the train was pulled by Savannah & Atlanta Railway steam locomotive 750, borrowed from the Atlanta Chapter, National Railway Historical Society for the occasion. This picture appeared on the front page of *The Atlanta Constitution* the next morning. (*The Atlanta Journal-Constitution/Dwight Ross Jr.*)

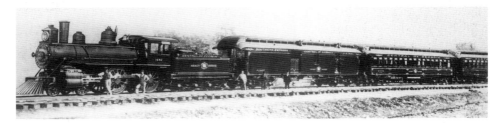

Like the *Nancy Hanks II*, the first *Nancy Hanks* ran between Atlanta and Savannah; in two back-to-back incarnations, it ran for a total of only ten months. Named after the racing horse that set a speed record for trotters in 1892, the Central of Georgia train was fast, too. Its quick pace even inspired a song: "Some folks say the *Nancy* can't run/ But stop, let me tell you what the *Nancy* done/ She left Atlanta at half past one and got to Savannah by the settin' of the sun/ The *Nancy*, she was so fast/ She burnt the wind and scorched the grass." This photograph dates from 1892 or 1893.

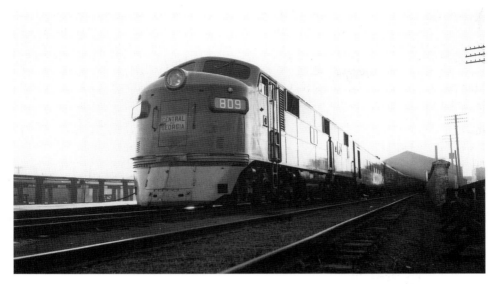

The beautiful Central of Georgia streamliner *Nancy Hanks II* has been freshened up for another long journey from Savannah to Atlanta. Here she departs with a new load of day trippers in Savannah's venerable passenger station in September 1948.

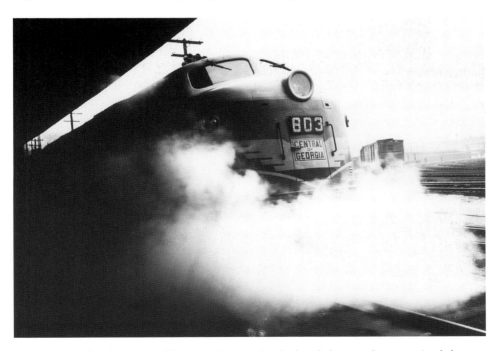

Above: Even after the reign of the steam locomotive had ended, steam heat remained the preferred means of heating passenger cars during the winter months, something which is underscored by this November 1951 photo of the *Nancy Hanks II*'s diesel locomotive discharging steam at Atlanta Terminal Station. Diesel passenger locomotives were equipped with small boilers known as steam generators to serve this purpose.

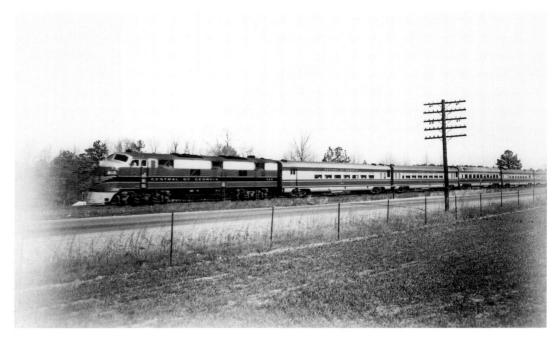

This must be her best side: The *Nancy Hanks II* on her way from Savannah to Atlanta, late 1940s.

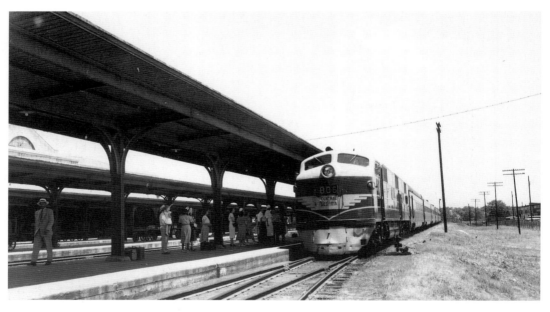

On her trip from Savannah, the *Nancy Hanks II* made scheduled stops in Griffin, Macon, and other Georgia cities. In this photo from 1951, she is pulling into Macon's Terminal Station, preparing to board new passengers bound for Atlanta. Macon's Terminal Station has been preserved; today it houses the local offices of the Georgia Power Company and the area convention and visitors bureau.

Right: The *Nancy Hanks II* is shown here with a seemingly endless string of passenger cars. Captured in September 1948, one year after her introduction, the *Nancy* is passing between the signal posts east of the Ocmulgee Bridge, near Macon.

Below: The engineer of the *Nancy Hanks II*, just a humble speck in the window of massive Central of Georgia E7 diesel–electric locomotive no. 805, gives a quick wave to the camera as the *Nancy* pulls away from Terminal Station in Atlanta on its way to Savannah, July 6, 1949.

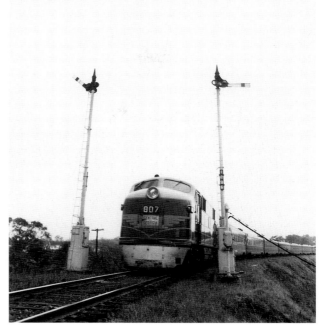

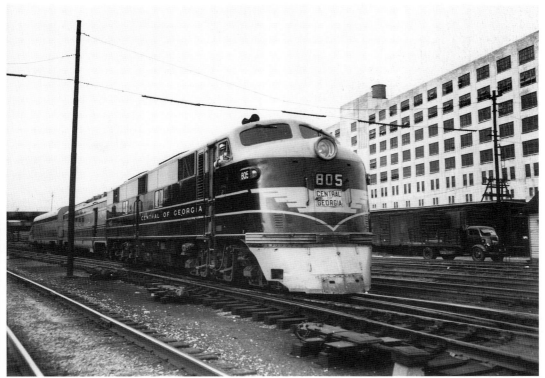

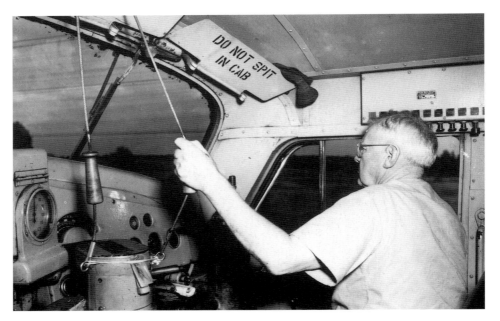

Engineer J.P. "Pat" Haffey heeds the admonishment "DO NOT SPIT IN CAB" as he sounds the horn of an E7 diesel powering the *Nancy Hanks II* on a trip from Macon to Atlanta, September 1948.

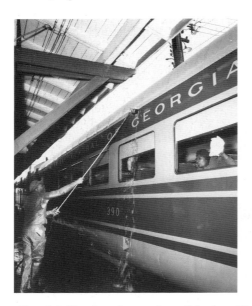

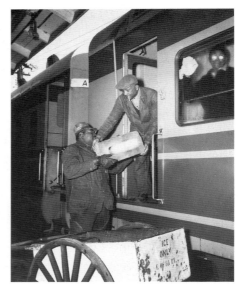

Above left: She doesn't stay clean all by herself. Central of Georgia car cleaners at Savannah's passenger station give the *Nancy Hanks II* a brush-up in March 1950.

Above right: Carmen loaded ice onto the *Nancy Hanks II*'s grille-lounge car before every outbound trip. While newer methods of refrigeration were in use on some railroads, the *Nancy*'s food service car still relied on the old ways of keeping its food fresh.

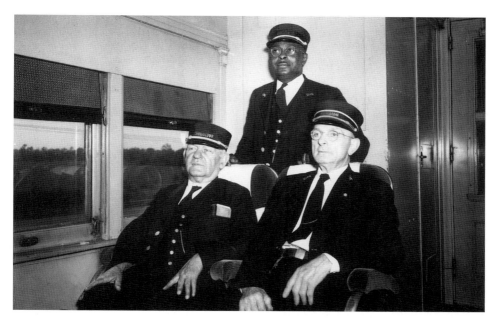

Here, from left to right, W.H. Mabry, conductor, Jim Stephens, porter, and J.R. McCamy, flagman, of the Central of Georgia's Macon Division pose for the camera aboard an old heavyweight coach on a passenger train in April 1949.

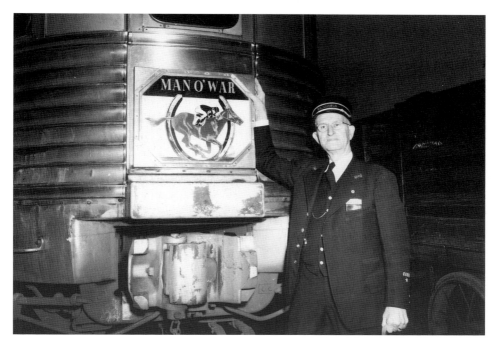

Central of Georgia Columbus Division conductor B.C. Bennett stands proudly at the rear of his train, Central streamliner *Man O' War*, in January 1951. The train was quite popular with military personnel headed to Fort Benning, an Army base located near Columbus.

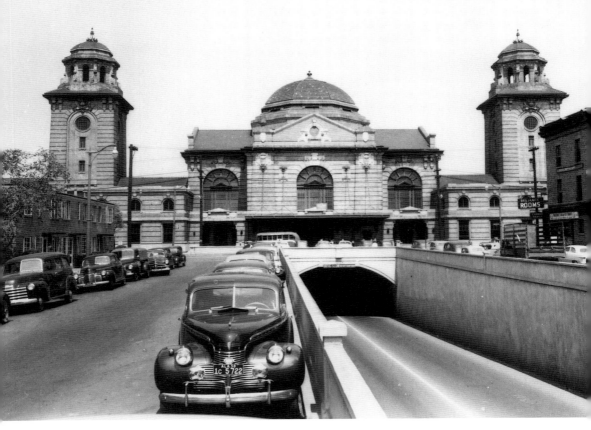

Above: This is a view of Terminal Station in Birmingham, Alabama, taken in August 1950. This beautiful building—designed by P. Thornton Marye, also architect of Atlanta's Terminal Station—was opened in 1909 to much fanfare, and once hosted some 54 trains per day. That number fell off through the years, however, and by 1969 only 9 trains regularly stopped at the Birmingham facility. The building was torn down and replaced by a smaller station, located nearby, in 1970. The replacement station was, in turn, torn down after its sole train—Southern Railway's *Southern Crescent*—was transferred to Amtrak and that company's Birmingham station in 1979.

Opposite below: Rounded-end tavern-lounge car no. 692, "Fort Benning," was built in 1947 by the Budd Company specifically for C of G's streamlined Atlanta-Columbus *Man O' War*. The car boasted seating for a total of 52 patrons in its tavern and observation lounge areas, and a rounded bar at its center. Well after its retirement by the Central, the car was acquired by Melco Labs, a telecommunications company. The firm used it to entertain clients throughout the 1980s. In this July 1949 photograph, the "Fort Benning" and the *Man O' War* are entering Atlanta's Terminal Station.

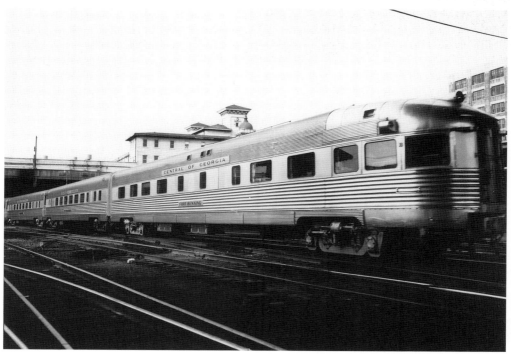

Right: Streamliner *Man O' War* is shown being turned on the wye at Columbus in this December 1948 view. Diesel-electric 809, on the point of the train, was less than a year old when this photo was made; an E7 model, this 1948 product of the Electro-Motive Division of General Motors generated 2,000 horsepower. 809 is trailed by a Railway Post Office car, a coach-baggage car, two coaches, and the rounded-end tavern-lounge car "Fort Benning."

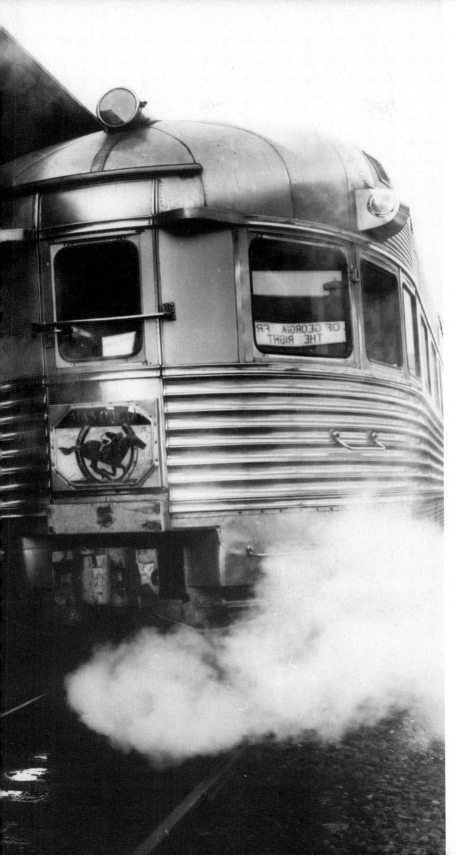

Initially, Central of Georgia streamliner *Man O' War* made two daily roundtrips between Atlanta and Columbus. It was quite a success; the train carried a total of 300,000 in its first two years of operation. The *Man O' War*, with tavern-lounge "Fort Benning" on the rear, is pictured here prior to a late-1940s run.

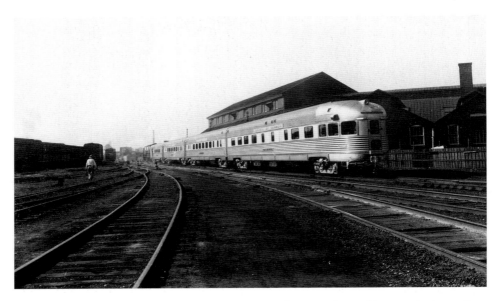

The *Man O' War* passes by the C of G's Columbus Shops in 1951, with a matched set of passenger equipment. On the train this day are tavern-observation lounge car no. 692, "Fort Benning"; coaches no. 664, "Fort Oglethorpe," and no. 665, "Fort McPherson"; and coach-baggage car no. 391, "Fort Mitchell." The 1947-built coaches 664 and 665 are still extant; no. 664 is now owned by the Southern Appalachia Railway Museum of Knoxville, Tennessee, and is used in occasional excursion service; 665—owned by a private individual—is stored at the Rocky Mountain Arsenal near Denver, Colorado.

Passenger train *Dixie Limited* is seen here by an onlooker peering from the cab of the *Nancy Hanks II* in July 1948. The *Dixie Limited* ran from Chicago to Jacksonville. Central of Georgia picked up the *Dixie* from the Nashville, Chattanooga & St. Louis Railroad in Atlanta and turned over the reins of the train to the Atlantic Coast Line in Albany.

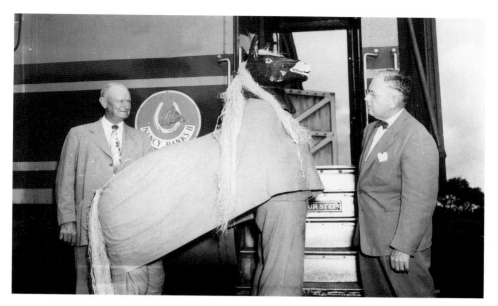

The costume department of the Central of Georgia was not quite as technologically advanced as their engineering department, or so it seems: here, a bad look-alike of the *Nancy Hanks II*'s racehorse namesake stands alongside a bad Dwight D. Eisenhower look-alike at the *Nancy Hanks II*'s sixth birthday celebration in 1953. In reality, that's passenger traffic manager T.J. Stewart on the left, and G.W. Stradtman, general passenger agent, on the right. Henry Powell and William Taylor, of the engineering and mechanical departments, respectively, "peopled" the horse.

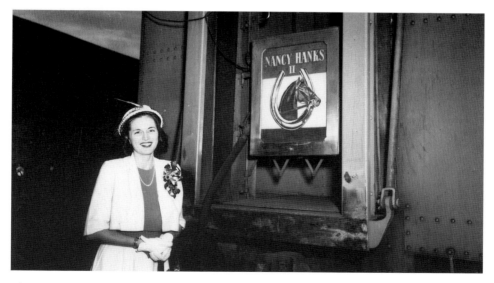

This young woman was crowned "Miss Nancy Hanks" for the celebration of the *Nancy Hanks II*'s second birthday. She is posing here on July 17, 1949, alongside the tail sign on the rear of the train. The drumhead featured a painted rendition of the streamliner's namesake, the late 19th-century trotter champion Nancy Hanks.

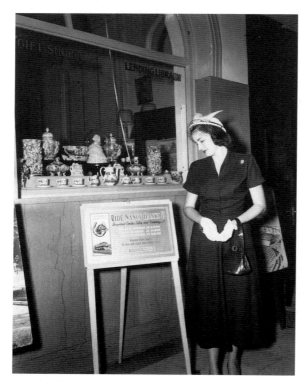

Left: On the day before the celebration of the *Nancy Hanks II*'s second birthday in July 1949, the young woman crowned "Miss Nancy Hanks" takes time out at the Hotel DeSoto in Savannah to check the *Nancy*'s daily schedule.

Below: At the *Nancy Hanks II*'s second birthday celebration, Central of Georgia employees W.W. Hackett, assistant general passenger agent, and W.M. Knapp, vice president, along with "Miss Nancy Hanks," partake of one of the more filling aspects of the festivities—the *Nancy*'s birthday cake.

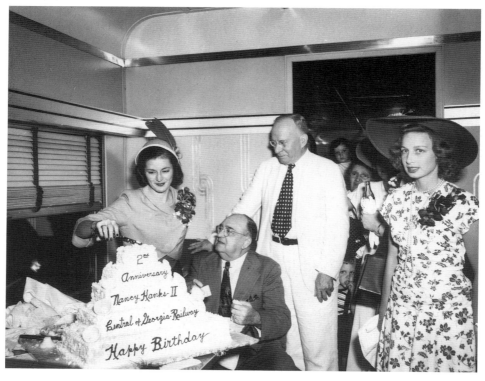

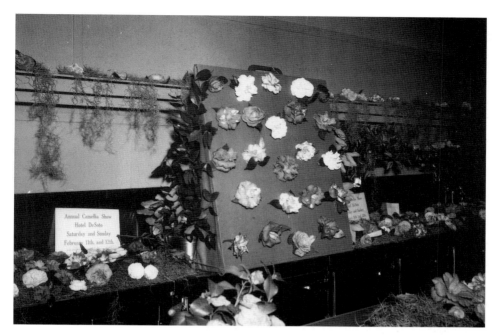

The lounge car aboard the *Nancy Hanks II* turned into a veritable greenhouse on February 4, 1950. In a promotion intended to promote Savannah's Annual Camellia Show, held at the city's Hotel DeSoto, some three thousand examples of the flowers were displayed aboard the train, and especially in the grille-lounge car. The flower display aboard the train—all cars of which were decked-out in camellias—was even exhibited to the public at Savannah on the night of February 3. All the flowers aboard the *Nancy* on her fragrant February 4 runs were donated by Chatham County growers.

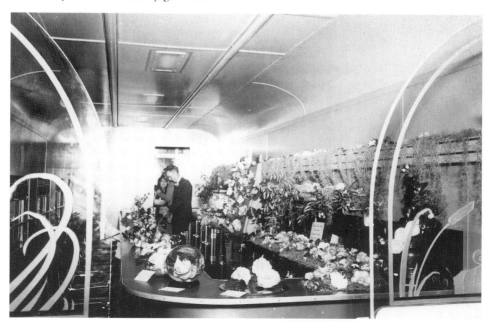

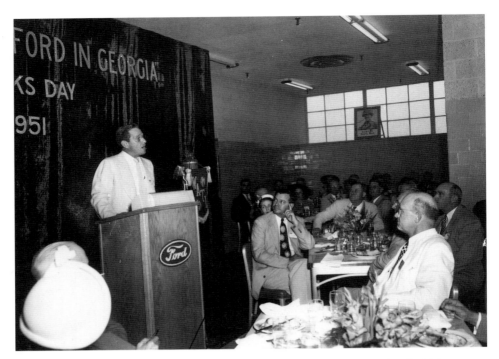

In 1951, the Ford Motor Co. joined in the *Nancy Hanks II*'s fourth birthday festivities with a celebration at their Hapeville, Georgia plant. The *Nancy* made a special stop at the plant for a luncheon featuring a speech by Governor Herman Talmadge (top, center). Below, partygoers were greeted with a rousing salute from the Third Army Band lining the walkway.

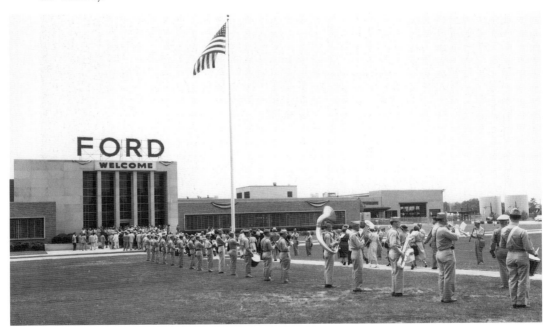

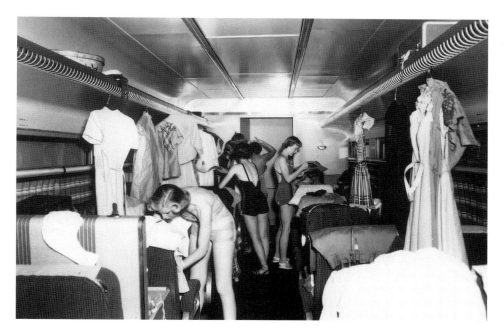

In the heyday of the *Nancy Hanks II*, Central of Georgia promoters used a number of attractions to bring more passengers on board. In a gimmick perhaps most commonly associated with the New York–Florida trains of the Seaboard Coast Line Railroad during the late 1960s, on-board fashion shows proved very successful. These shots show some of the models who participated in the 1951 show. Included among them were Maid of Cotton Miss Elizabeth McGee of Spartanburg, South Carolina, and ten students from the Academy of Charm modeling school in Atlanta.

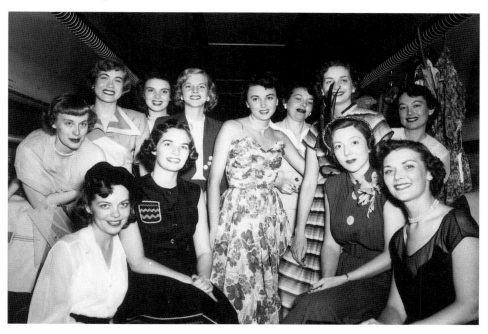

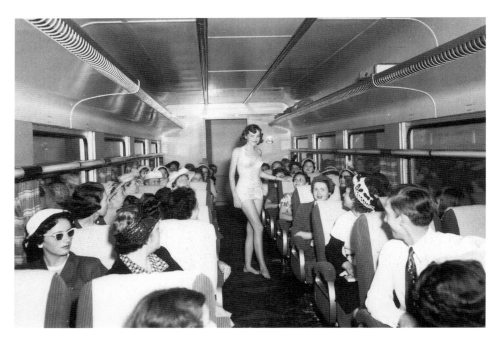

Another model in the *Nancy*'s 1951 fashion show was bathing suit-clad Betty Sue Huff, shown here modeling in the aisle of one of the train's coaches.

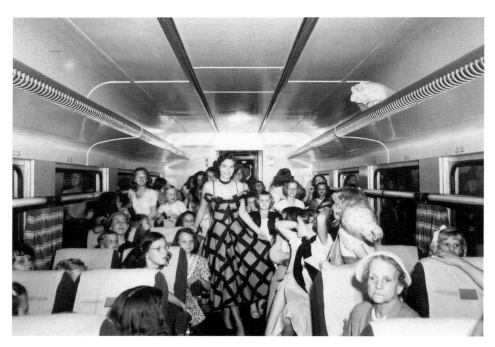

Fashions from the Franklin Simon department store were featured in another on-board fashion show on the *Nancy Hanks II* on August 25 and 26, 1952. Here, model Elizabeth Ann Matthieu shows off the latest in dresses to passengers aboard the *Nancy*.

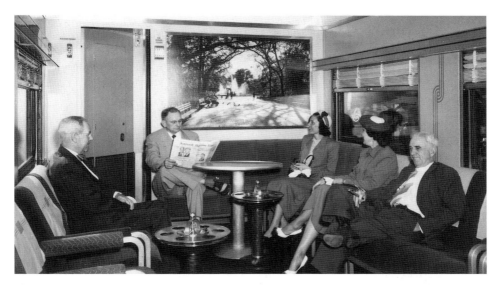

These prominent Atlantans enjoy a beautiful new mural on the *Nancy Hanks II*. The mural in the lounge section of grille-lounge car 691 depicted Forsyth Park in Savannah and was hand-colored by Savannah Shops paint department foreman Gus Riedel. Seated are L.W. McRae, vice president of Citizens & Southern Bank; George McGee, a member of the State House of Representatives; Mrs. Grace Gray; Mrs. Vivian Wise; and L.M. Clarkston, a Georgia State Health Department official.

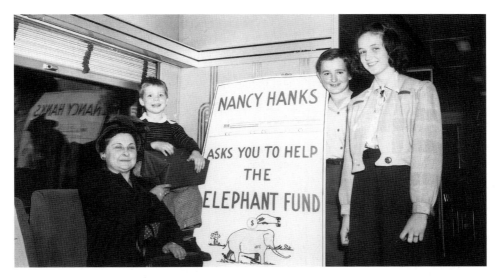

Not only did the *Nancy Hanks II* offer a comfortable ride from Savannah to Atlanta, but she was an activist, too! Students from Atlanta's Whiteford Elementary School, on board the *Nancy Hanks II* in March 1950, raised $19.86 to help the Atlanta Zoo buy an elephant to replace the recently deceased Coca, the celebrated animal given to the Grant Park zoo by Asa G. Candler Jr. (son of the founder of The Coca-Cola Company). Ultimately, the program was a great success: enough money was raised to buy *two* elephants, named Coca II and Penny.

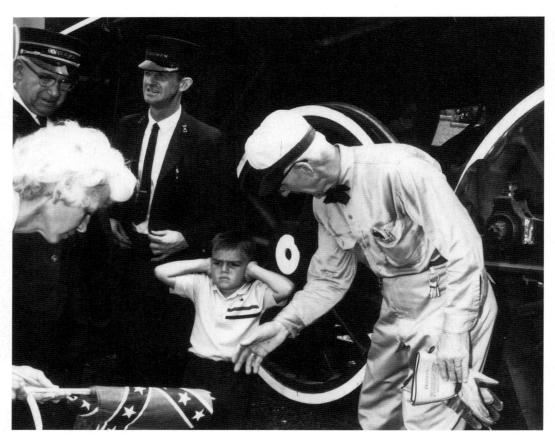

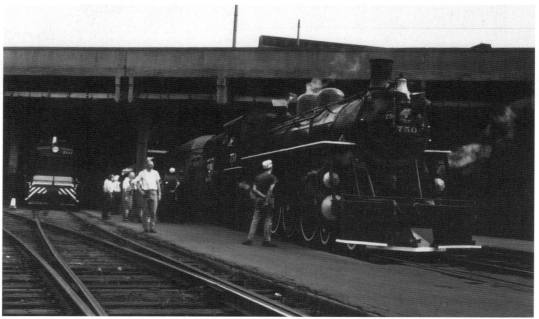

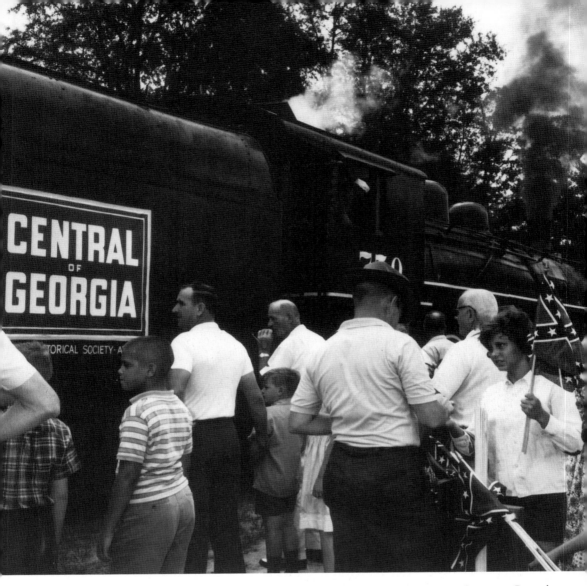

A crowd of people await the call of "All A-Board!" for a reminiscent steam excursion over Central of Georgia rails to and from Jonesboro on August 29, 1964. The special 45-minute trip took passengers into the middle of the 100th anniversary reenactment of the Battle of Jonesboro. Savannah & Atlanta Railway steam locomotive 750 pulled the train. No. 750—a 4-6-2 Pacific-type—was originally built in 1910 by the American Locomotive Company for the Florida East Coast Railway; later in life, the locomotive was sold to the Savannah & Atlanta Railway. The engine, owned in retirement by the Atlanta Chapter, National Railway Historical Society, bore temporary Central of Georgia Railway markings especially for this trip. C of G had acquired the Savannah & Atlanta in 1951. These photos were taken at Jonesboro *(this page and opposite above)* on the return trip, and at Atlanta *(opposite below)* on the outbound leg.

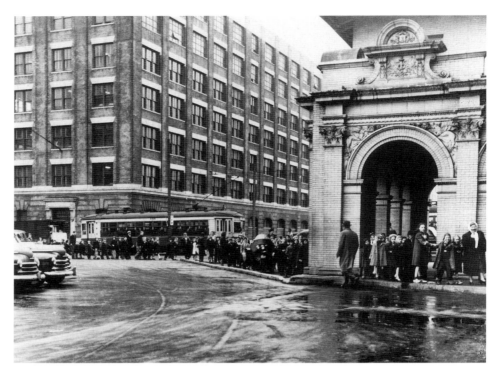

Many Georgia schoolchildren took school day field trips aboard the *Nancy Hanks II* in 1948. The kids of Atlanta's Crew Street School were among the lucky ones; they are shown here walking to Atlanta Terminal Station and in its waiting room before their 1948 trip.

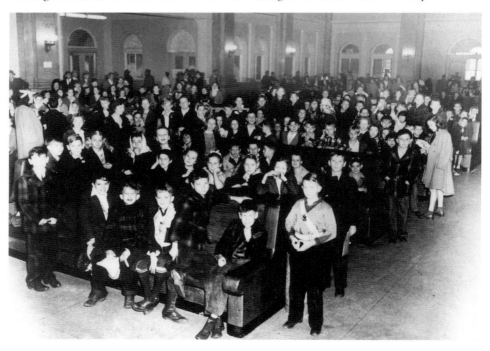

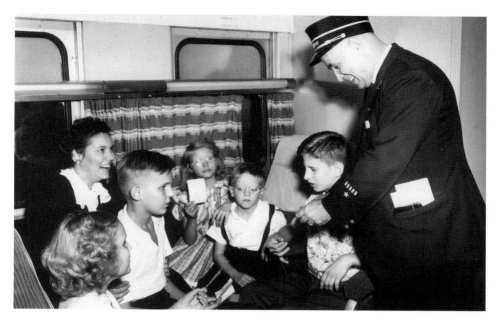

H.M. Watson, conductor of the *Nancy Hanks II*, converses with a group of children from an Atlanta school for the blind who were riding the *Nancy* between Atlanta and Griffin on a 1948 school trip. Pictured, from left to right, are: Ann Stephens, parent Mrs. Otis Stephens Sr., Otis Stephens Jr., Patricia Smith, Mickey Smith, Fred Shockley, and Conductor Watson.

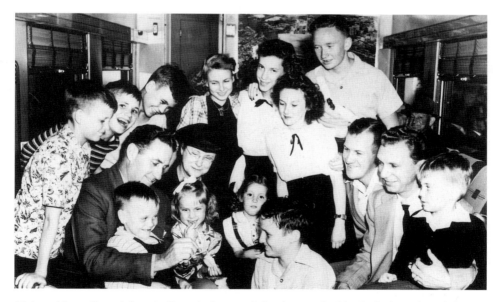

Girls and boys from Atlanta's Georgia Avenue School were doubly thrilled on their field trip in April 1948. First, they got to ride the beautiful Central of Georgia streamliner *Nancy Hanks II*; and second, they were entertained on board by two star players of the Atlanta Crackers, Walter Stockwell and Charlie Glock, on the right, as well as Atlanta Crackers Coach Ki Ki Cuyler, on the left.

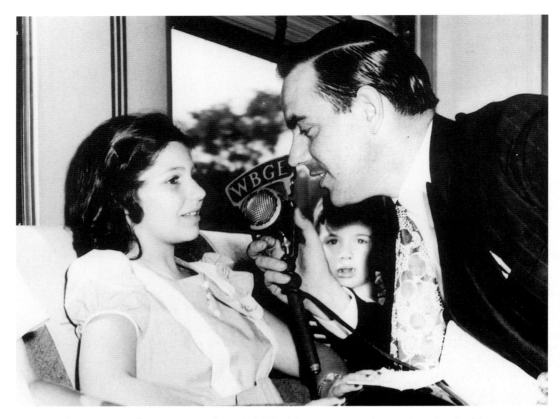

Above: Jack Dromey, radio announcer for WBGE in Atlanta, gets up close and personal with young Ann Moscow during a broadcast on board the *Nancy Hanks II* in May 1948. Moscow and her class were taking a school day field trip on board the *Nancy*.

Opposite: The Central of Georgia station agent at Guyton, Georgia, proudly poses with his charge during the late 1940s or early 1950s. Guyton's town council paid for the billboard which sat atop the Victorian-style depot and advertised the *Nancy Hanks II*; the Dodge pickup truck in the photo was a company truck assigned to the little burg. Guyton—about 20 miles west of Savannah in rural Effingham County—was a flag stop for the *Nancy*.

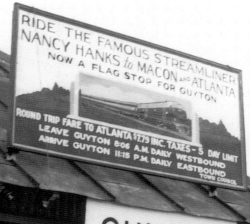

RIDE THE FAMOUS STREAMLINER
NANCY HANKS *to* MACON *and* ATLANTA
NOW A FLAG STOP FOR GUYTON

ROUND TRIP FARE TO ATLANTA $7.79 INC. TAXES – 5 DAY LIMIT
LEAVE GUYTON 8:06 A.M. DAILY WESTBOUND
ARRIVE GUYTON 11:15 P.M. DAILY EASTBOUND
TOWN COUNCIL

GUYTON

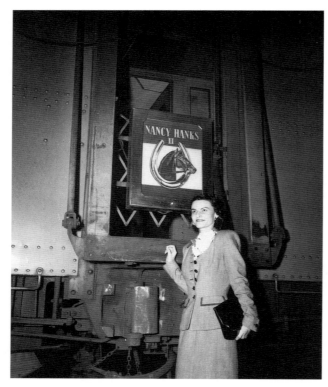

Left: It sure didn't take long for the number of passengers who had ridden the *Nancy Hanks II* to reach half a million: Mrs. James C. Overall, the director of the Veterans Guidance Center at Armstrong College in Savannah, was honored as the 500,000th passenger of the *Nancy* when the train was not yet three years old.

Below: This charming couple owes much to the *Nancy Hanks II.* The former Miss Martha Perkins of Zebulon, Georgia, was engaged to Mr. James C. Stanley of Griffin on board the *Nancy* on a trip from Atlanta to Griffin. This photo was taken in January 1950, just after their marriage, when the new Mr. and Mrs. Stanley rode the *Nancy* from Griffin to Savannah to begin their honeymoon.

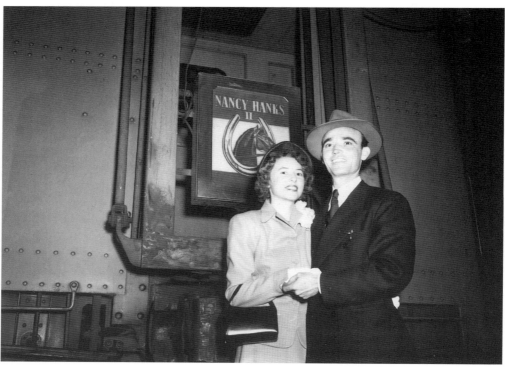

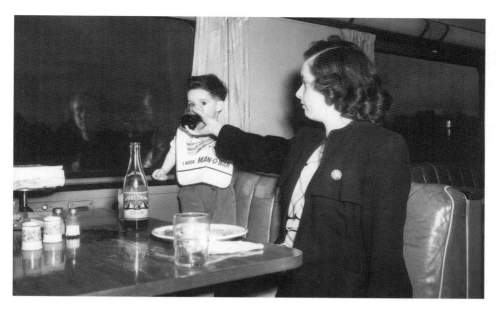

The Central of Georgia provided for its passengers, even down to the smallest details, on board the streamliner *Man O' War*. Mrs. Edwin H. Davidson is very appreciative of the *Man O' War* bib provided for her son Edwin, who is enjoying a cold beverage in the tavern-lounge car in May 1949. The plastic bibs were "given to the 'littlest' diners aboard" the *Man O' War*, according to the July 1949 issue of the *Central of Georgia Magazine*.

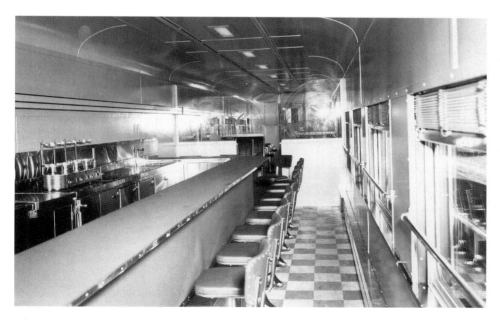

This scene on Central of Georgia grille-lounge car 691 could easily be duplicated in any 1950s diner without wheels: checkered tile, bar style seating, and plenty of chrome. Central of Georgia short-order cooks were always ready to tend the grill when a hungry *Nancy Hanks II* traveler called.

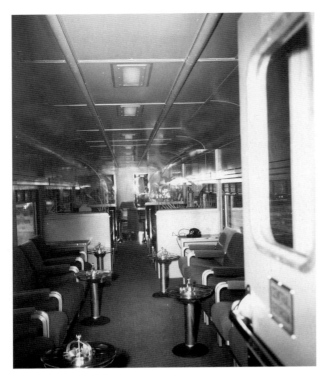

If you wanted a bite to eat, Central of Georgia could give it to you in comfort. Grille-lounge car 691 gave weary passengers a comfortable place to enjoy a sandwich and a smoke. This photo was taken in September 1948, just prior to the car's inaugural run. The car was originally built by the Pullman Company in 1922 as a coach; in September 1948, it was converted to a lunch counter and lounge car by the passenger car shops at Savannah for service on the *Nancy Hanks II*. It functioned as a backup to the similar 1947-built grille-lounge that was regularly assigned to the train.

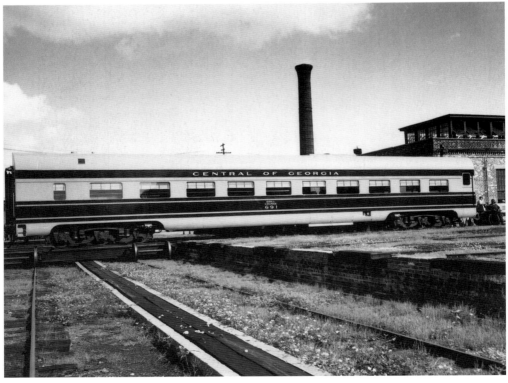

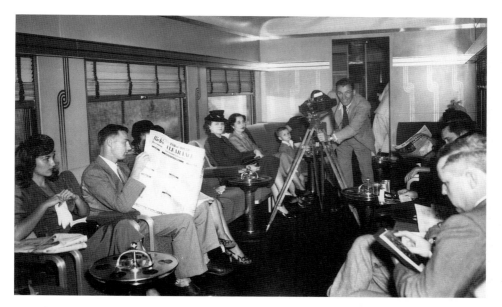

Just a bit to the left . . . and . . . ACTION! The gentleman smiling for the company photographer is taking moving pictures aboard the *Nancy Hanks II* for television use on WPIK in New York City. He didn't have to go far to find suitable subjects, judging by this September 1948 photo.

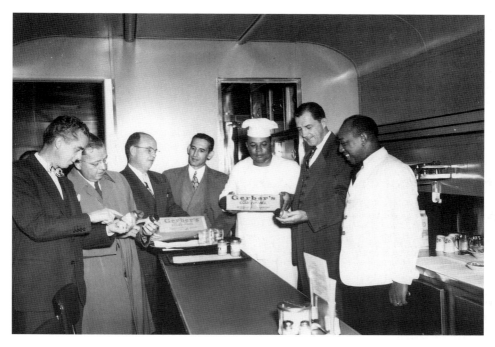

The gentlemen in this November 1948 photo are excited to see that the *Nancy Hanks II* has introduced baby food to its menu. The men standing are representatives from Gerber and the Central of Georgia Railway—and are all proud parents of this new addition.

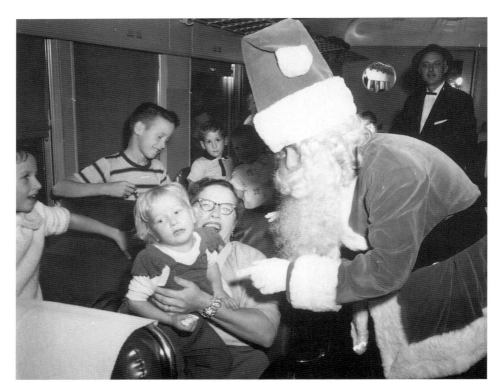

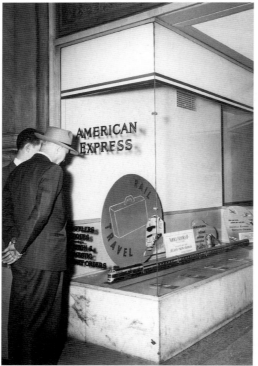

Above: On December 3, 1958, the C of G operated two *Santa Claus Specials* between the towns of Dover and Statesboro, Georgia, in excursions sponsored by the Statesboro Merchants Association. As the name implies, area children and their families who rode were delighted by the presence of Santa aboard the 13-coach train. Here, St. Nick visits with a rather wary youngster on one of the 10-mile runs. When not making his way through the chair cars, Santa rode aboard a specially painted wooden caboose attached to the rear of the *Specials.*

Left: American Express encouraged Atlantans to leave home the *Nancy Hanks* way in this 1950 storefront display at American Express's downtown offices. In this joint display with the Central of Georgia Railway, vacationers were encouraged to bring along the peace of mind that only American Express Travelers Cheques can offer.

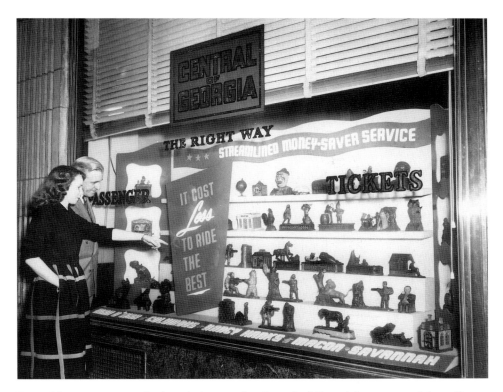

Potential customers peer in the windows at the Central of Georgia's passenger ticket office located in the Piedmont Hotel, 95 Forsyth Street, Atlanta, in 1952. One of the displays featured a collection of coin banks made available for display by the Citizens & Southern Bank and its president, Mills B. Lane Jr.

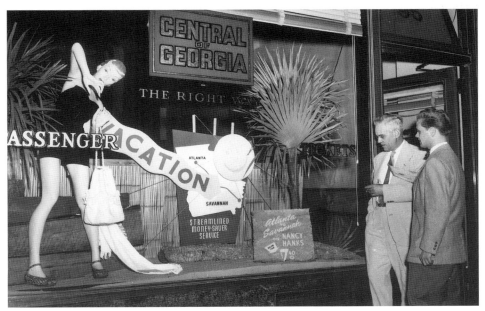

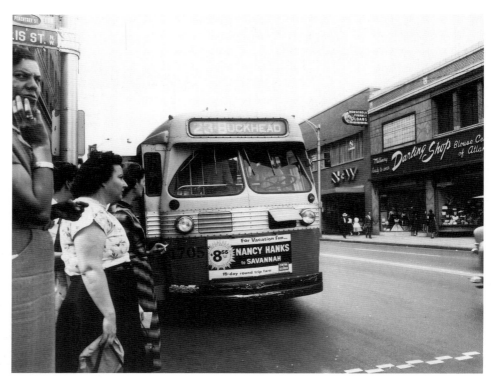

A battered Atlanta Transit Company bus featuring an advertisement for the popular streamliner *Nancy Hanks II* was photographed on Peachtree Street in 1956. Atlantans seeking a vacation getaway needed only $8.55 for round-trip excursion fare to Georgia's historic colonial city.

two

People are Central

The Faces and Places of the C of G

Through the years, the human side of railroading was very often the focus of articles in the *Central of Georgia Magazine* and the company's other "house organs." Photos of workers and their after-hours hobbies were frequently published alongside columns by railroad officials, news on legislation affecting the industry, safety mantras, and syndicated inspirational columns from well-known writers, such as Norman Vincent Peale. Pictures of pet raccoons and retirement parties, basketball and softball teams, and marching bands are all present in the photo files now located at the Atlanta History Center Library/Archives.

To many, railroading was a family affair, with fellow railroaders making up their extended family. And thanks to the *Central of Georgia Magazine*, keeping up with family members didn't have to wait for Christmas card season.

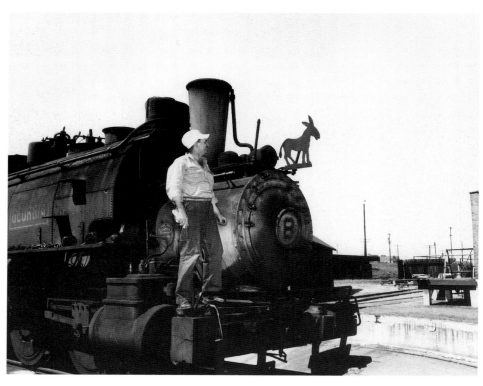

The long suffering switch engine of the Central of Georgia's Macon Shops, lovingly referred to by employees there as "Old Maude," was photographed in September 1950. The diminutive little 0-6-0, built in 1886, by this time sported a silhouette of a mule just above her headlight, perhaps alluding to Maude's stubborn nature in her role as shop "mule."

In this photo taken for a 1954 article in the *Central of Georgia Magazine* entitled "I Drive A Diesel," engineer and author E.C. Bean and his son marvel at no. 804, one of the diesel engines regularly used to pull Central of Georgia streamliner *Nancy Hanks II* from Atlanta to Savannah. This shot was taken at the diesel shop in Macon, Georgia, in October 1948. No. 804, an E7 model, was built by the Electro-Motive Division of General Motors in 1946.

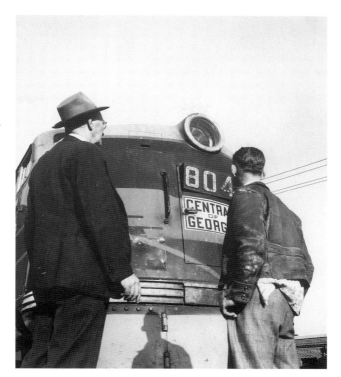

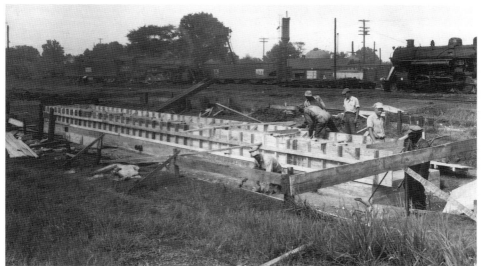

Cedartown, in North Georgia's Polk County, was the site of the construction of a new engine track and inspection pit for diesel-electric locomotives in the early 1950s. Here, the new pit is shown under construction at the direction of C of G foreman I. Earl Farmer. In the background, two soon-to-be-replaced MK class 2-8-2 steam locomotives, no. 635 and no. 649, look on. Both engines were not long for the world when this photo was made; 1916-built no. 635 was retired in August 1952, while 1923-built no. 649 was retired in May 1951.

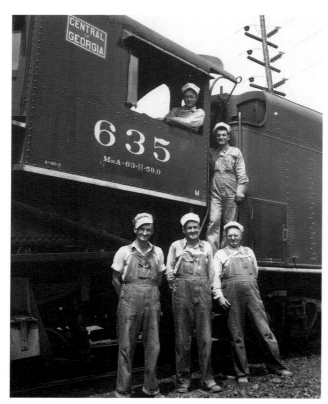

Left: These kindly gentlemen worked together for years on the Central in Colgate, Alabama. This photograph captures them in 1948 with engine no. 635, an MK class 2-8-2 built by Lima in 1916. The steam locomotive was retired in August 1952.

Below: This photo, taken at the C of G depot in Trion, Georgia, in 1949, is proof that segregation was still very much a part of southeastern railroads in the mid-20th century. Trion, a textile mill town in North Georgia's Chattooga County, was 37 miles north of Rome on Central's Griffin-Chattanooga Line.

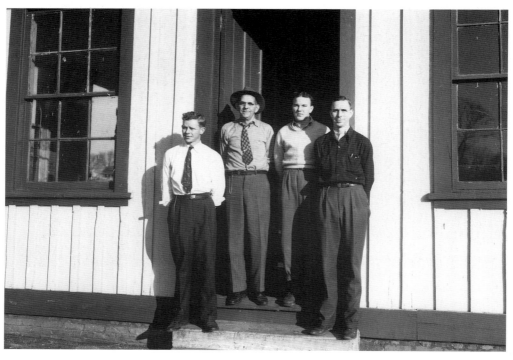

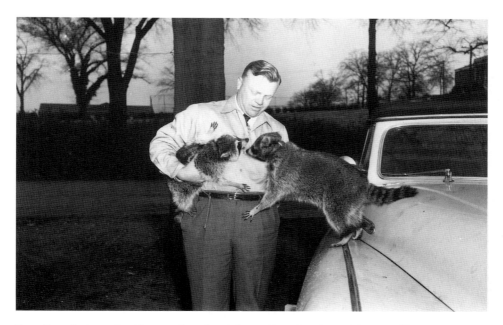

Pete Crawford, section foreman based at Athens, Georgia, plays with two of his pet raccoons as photographed for the *Central of Georgia Magazine*'s March 1950 issue. Crawford told the publication's editors that the raccoons made excellent playmates for his children, and "delight[ed] in sitting on top of the windshield as he [sped] down the road at 50 and 60 miles an hour in his roadster."

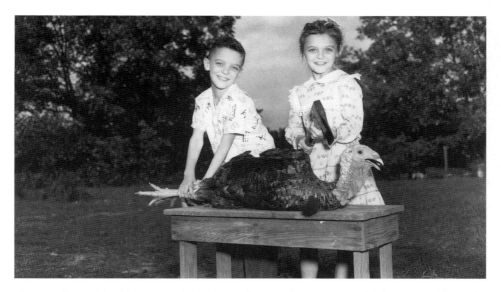

The cute little girl with the ax is Martha Jane Joyner, the nine-year-old daughter of Central of Georgia flagman J.H. Joyner. The young man holding down the turkey for slaughter is her twin brother, Joe Howard Joyner. The proud parents of these tikes liked the picture, and so did the Central: it was used as the front cover of the *Central of Georgia Magazine* in November 1948.

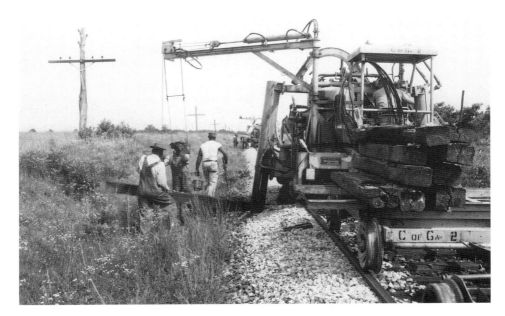

This photograph from the November 1956 issue of the *Central of Georgia Magazine* shows a track gang hard at work replacing rotten wooden crossties on the C of G's Americus [Georgia] District. They were aided in their endeavor by an early version of a mechanical tie-handler, which took much of the backbreaking work out of the task of exchanging old ties for new.

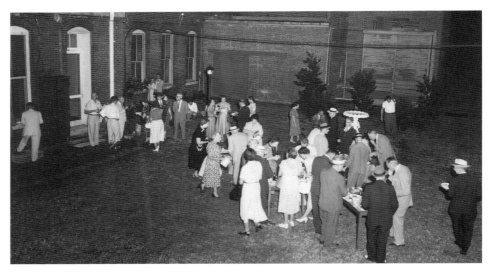

During 1955, the Central's Savannah Employees Club took on the task of beautifying the courtyard between the Red and Gray buildings of the company's headquarters complex in Savannah. Once the new landscaping and plantings were in place, the improved space quickly became a popular site for events such as the Employees Club's annual Christmas party and other company-sanctioned social events. The eating and drinking appear to be in full swing in this picture from the mid-1950s.

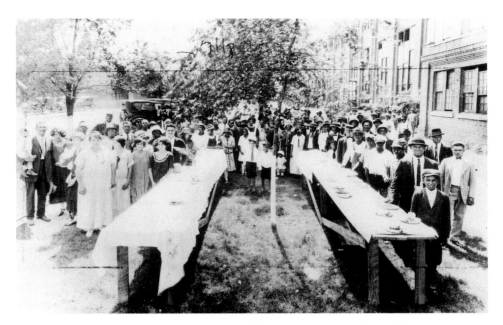

Members of the Central of Georgia's Colored [locomotive] Fireman's Fuel Association are shown at a fall barbecue at the Savannah Shops, *c.* 1920. A number of company officials—all of whom were white—". . . showed their appreciation of the colored firemen by attending the barbecue and had a [separate] table set aside for that occasion," in the words of the photographer.

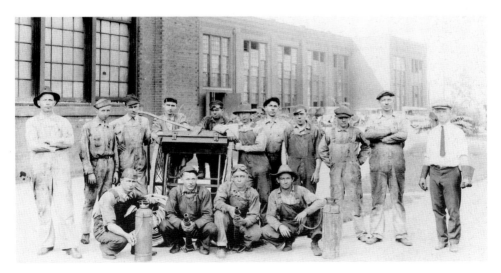

A Central of Georgia firefighting team poses with their equipment at the Macon Shops, *c.* 1915. With them is a hose reel cart, used for fire protection at industrial complexes such as railroad repair shops in the days before mechanized fire equipment. This picture may be of Macon Shops' hose reel team. Being a member of a hose reel team was a popular avocation for blue-collar industrial workers in the days before WW I; teams competed against the clock and other teams in athletic events designed to showcase their firefighting prowess.

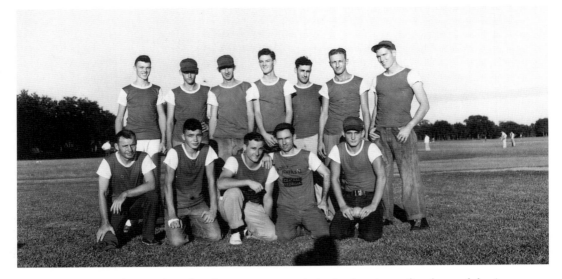

Working together on the railroad creates a camaraderie that lasts long after the workday is over. Here, a group of employees who played on the Central of Georgia softball team in Savannah poses for a picture after a game. The photo appeared in the September 1949 issue of the company magazine.

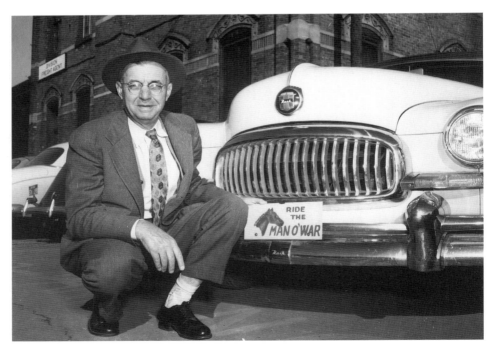

This gentleman is proud of his Nash automobile, but R.G. Jefferson was also proud of the *Man O' War*; here he showed off his auto's newly added ornamentation in 1952. Jefferson was an assistant general foreman at the Central's Columbus Shops; Jefferson's colleague A.L. Hollingsworth created the special tag for his friend.

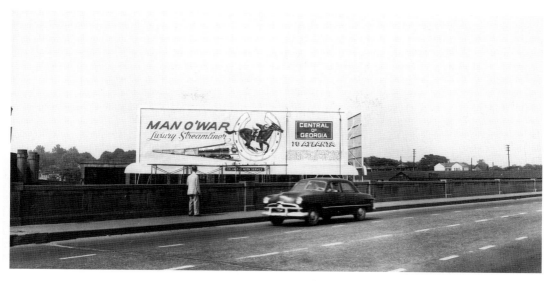

This man is obviously awestruck, and why shouldn't he be? The *Man O' War* was an awe-inspiring sight, even on a billboard. This particular advertisement for the Central of Georgia streamliner sat atop Central's Columbus Shops in 1951 and was seen by motorists and pedestrians alike from this heavily traveled viaduct in town.

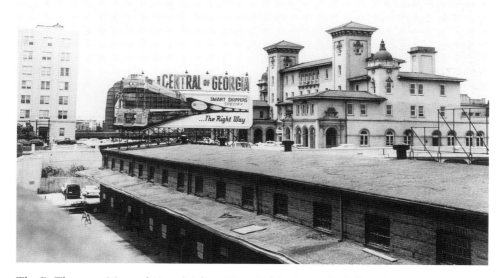

The P. Thornton Marye-designed Atlanta Terminal Station and a billboard advertising the Central of Georgia's freight service are seen here in a *c.* 1964 photograph. At left are the Southern Railway's 99 Spring Street offices, across Mitchell Street from the station. When Terminal Station was closed for good in June 1970, the *Nancy Hanks II* was relegated to a small ticket office and waiting lounge created for passengers in the Southern Railway building; Terminal Station's other remaining passenger trains—Southern Railway's *Crescent* and *Southerner*—were transferred to Southern's Brookwood Station on the north side of the city.

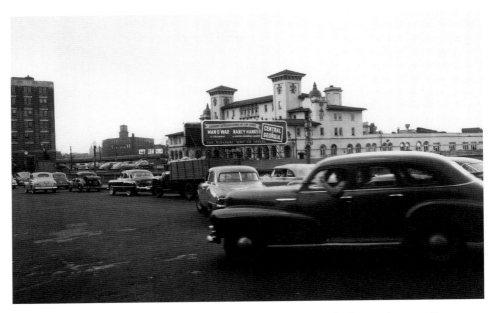

"The Pleasant Way to Travel." So said this billboard for Central of Georgia streamliners *Nancy Hanks II* and *Man O' War* that sat atop the freight and express building adjacent to Atlanta's Terminal Station. With *Nancy* going to Savannah and *Man O' War* to Columbus, Atlantans had a choice of two forms of pleasant travel.

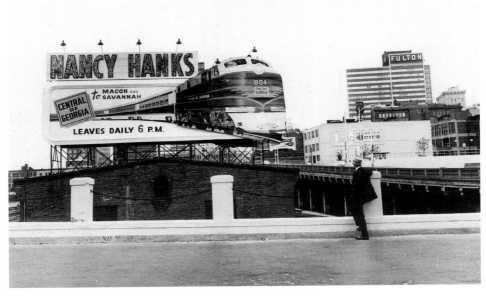

This is the same Atlanta Terminal Station-sited billboard as it appeared *c*. 1964. Evident in this picture are other preeminent Atlanta buildings and institutions, including Rich's department store (just to the right of the Spring Street viaduct), the Fulton National Bank Building, and, at right, the beaux-arts Third National Bank Building.

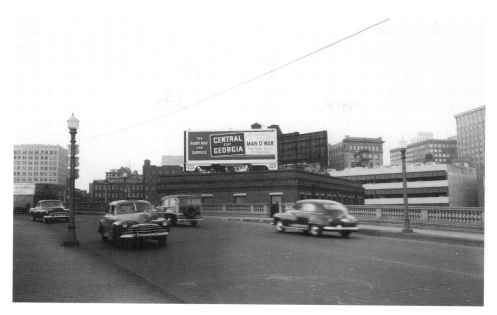

The billboard confirms it: in 1949 Atlanta, the Central of Georgia was "The Right Way for Service" for both freight and passengers.

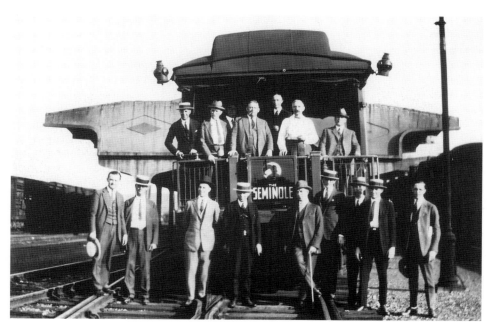

A group of busy executives about to leave aboard the Savannah connection to the Chicago-Florida *Seminole* take a moment for a picture. The connection met the *Seminole* at Columbus and was usually punctuated by this ten-section heavyweight sleeper-lounge car, complete with observation platform, which ran all the way through to Chicago.

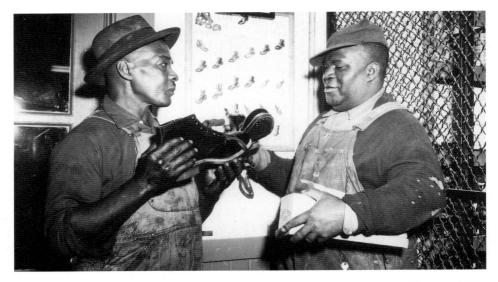

Two Central of Georgia shop employees look over the safety shoes just issued them in 1950. Like most railroads, Central strongly emphasized safety rules at all of its facilities. The issuance of steel-toed shoes, provided to C of G employees by the Safety First Shoe Company, was but a single element in the railroad's comprehensive worker safety program.

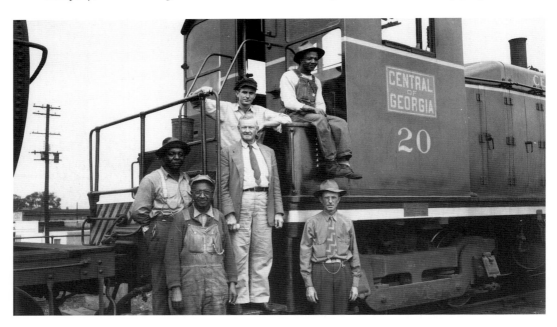

NW2 diesel locomotive no. 20 became a backdrop for this photo of colleagues at the C of G's Macon yard in September 1948. The railroaders from left to right are: (front row) switchman Julius Johnson, fireman James Taylor, foreman R.E. Atwater, (standing on steps of engine) engineer W.W. Sherwood, switchman C.J. Maxwell, and (sitting on locomotive) switchman Willie Taylor. No. 20 was one of the few diesels delivered to the Central prior to WW II, having been built by General Motors' Electro-Motive Division in 1941.

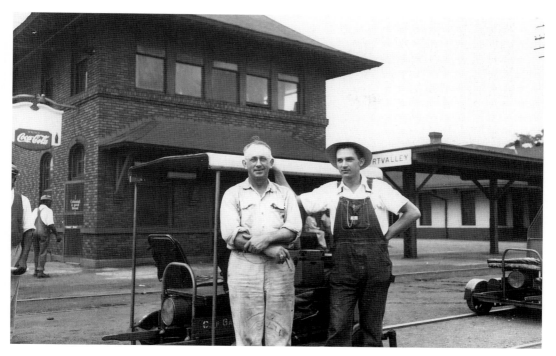

Assistant signal maintainer J.E. Treadwill, chatting with signal maintainer J.L. Gassett in Fort Valley, Georgia, pauses for a photograph after work in September 1949.

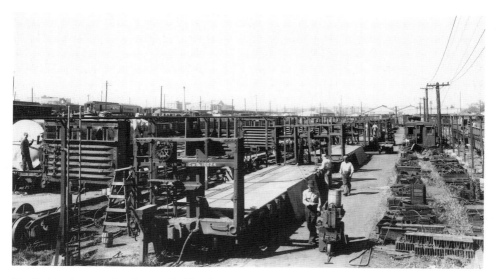

Replacing the wooden floors of old pulpwood cars with steel decking was a top priority for the railroad's Macon Shops, according to the October 1950 issue of the *Central of Georgia Magazine*. The pulpwood industry in Georgia, Alabama, and the Southeast was booming in the early 1950s, and Central forces were hard at work repairing and rebuilding cars for pulpwood service in this photograph. All of the men worked under the direction of Tom C. Perkins, superintendent of the car department at Macon.

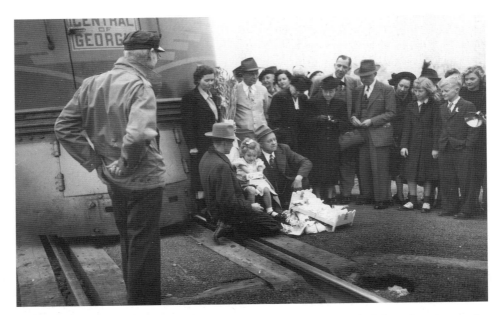

Little Grace Purcell of Lovejoy, Georgia, enjoyed waving at Central of Georgia trains much like everyone else. Unlike most others, however, Grace didn't have hands to wave with; she was born without arms below her elbows. In 1948, the crew of the *Southland*, after seeing her wave for weeks, decided to raise money to buy Grace prosthetic arms. When the *Southland* stopped in Lovejoy on December 23, 1948, Engineer H.R. Lee descended from the locomotive cab and presented Grace with $4,000 raised by the crew.

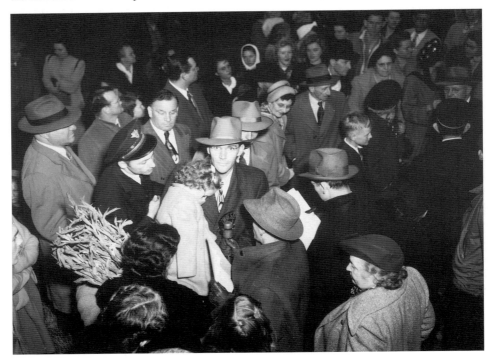

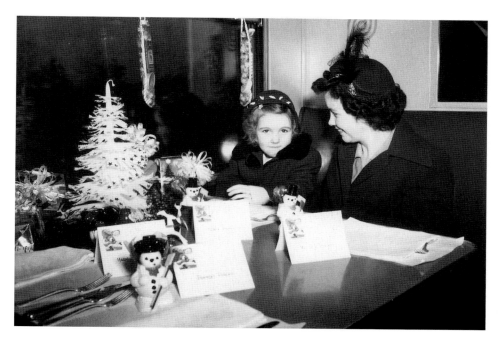

Grace Purcell was given a party on board the *Nancy Hanks II* on December 21, 1950. She is captured here enjoying her trip and her new prosthetic limbs.

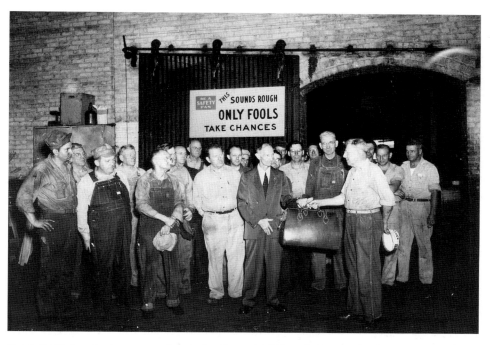

Frank L. Duhse, lead patternmaker at the Central of Georgia Savannah Shops, is presented with a traveling bag upon his retirement in October 1949. His coworkers took no chances— they had been planning the party for weeks. Duhse had been with the C of G since 1922.

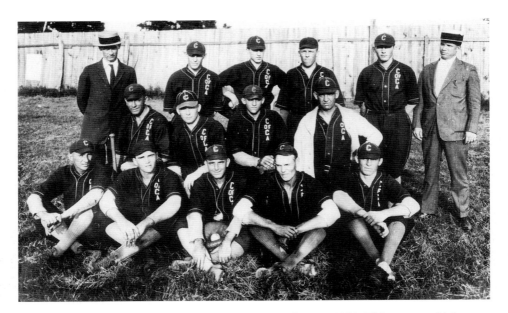

Central of Georgia's Savannah baseball team is shown here, *c.* 1920. This team—which was made up exclusively of Central employees—followed the proud folkways of previous stellar C of G company baseball teams in the city.

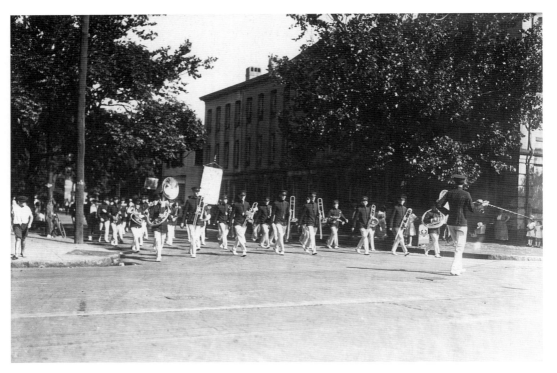

The Central of Georgia band performs at Savannah *c.* 1930, most likely for the city's popular St. Patrick's Day parade. The parade continues to be held downtown every year.

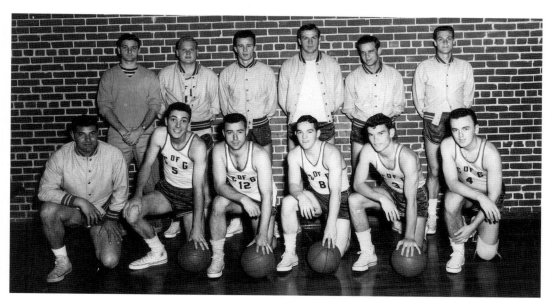

Members of a Central of Georgia men's basketball team strike a classic pose, *c.* 1950.

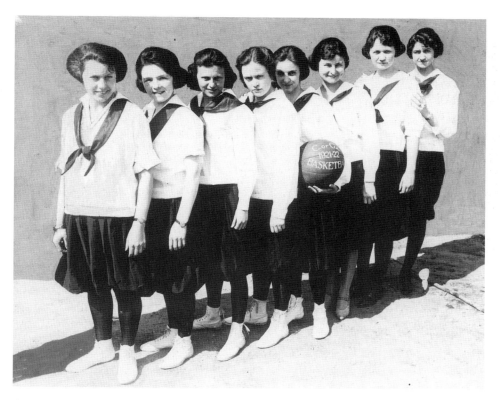

Company sports weren't just for the men; members of a Central of Georgia women's basketball team pose together for a 1922 portrait.

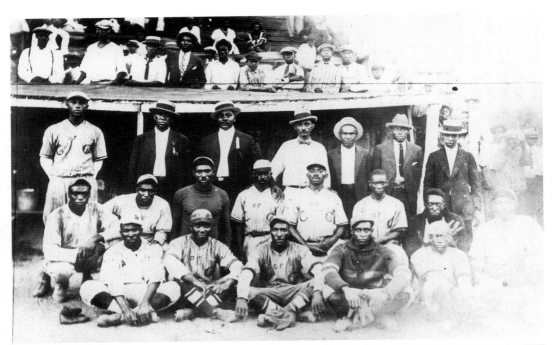

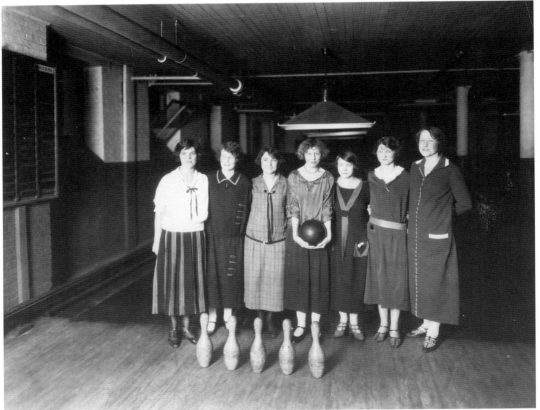

58

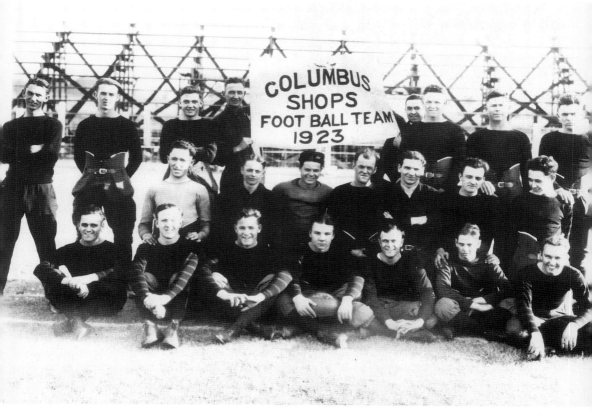

Above: Pictured here is the Central of Georgia Columbus Shops football team of 1923.

Opposite above: Pictured here is an African-American Central of Georgia baseball team after a game in the 1920s.

Opposite below: These happy-go-lucky women were all a part of the Central of Georgia's teams in a Savannah bowling league in the 1920s.

These special stalls for horses were built on the S.S. *Dorothy*. The race horses in this photograph, whose names were Mort O, Amashonks, and Sun Volo, were owned by Antonio Rodriguez (right). They were loaded aboard ship in Savannah at Central of Georgia berth no. 22 and set sail for Puerto Rico aboard the *Dorothy* in March 1949.

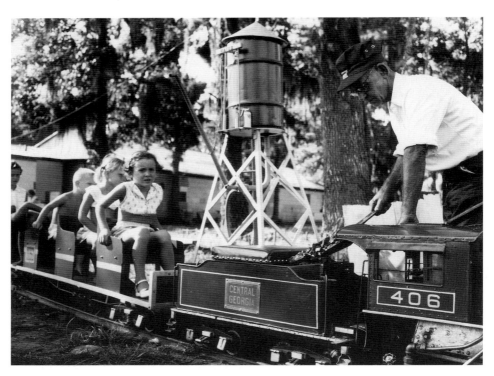

J.L. Owen, a machinist in the Central of Georgia's shops at Savannah, loads coal in the tender of miniature live-steam locomotive no. 406, which he built and maintained. Owen regularly took area youngsters for rides behind 406 along the 700-foot circular track located on his ranch just outside Savannah.

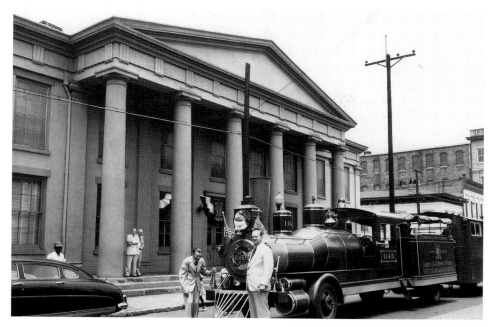

The *Nancy Hanks III*, built in the Central of Georgia's Macon Shops, was owned by Macon's American Legion 40 and 8 Honor Society. It was used by the social organization in parades and at special events. In 1951, Macon Mayor Lewis Wilson and Ben Chatfield of WMAZ–Macon posed in front of the *Nancy Hanks III* with the railroad's Gray Building offices in Savannah directly behind them. Later, Macon Mayor Lewis Wilson (below, foreground) paused for a photo while standing in the doorway of the *Nancy Hanks III*.

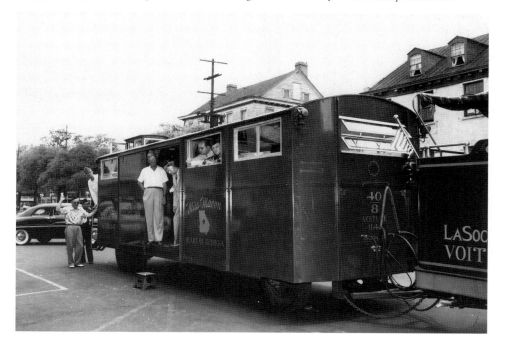

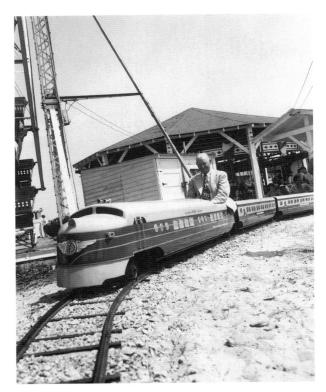

The miniature streamliner *Little Nancy Hanks*, in operation at Eastin's Ride Center at Savannah Beach, carries passengers at full throttle in August 1948. That's T.J. Stewart, Central of Georgia's passenger traffic manager in Savannah, at the control stand of this pint-sized train in the photo at left.

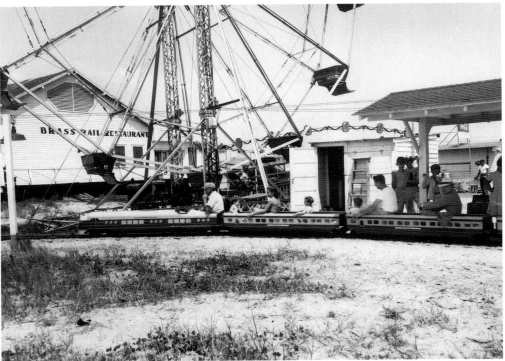

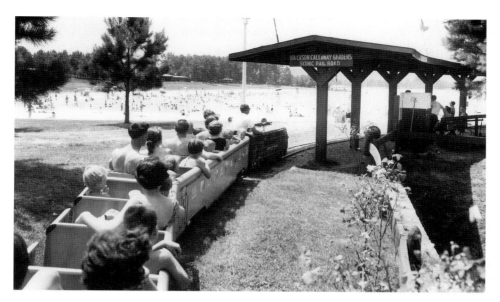

Callaway Gardens, the still-popular tourist attraction in Pine Mountain, Georgia, boasted a scenic railroad complete with a miniature Central of Georgia Railway streamliner during the late 1950s. Inspiration for the train's paint scheme came from the C of G's *Man O' War*, which stopped at Pine Mountain daily on its way from Atlanta to Columbus. This photograph shows the gasoline-powered miniature train in operation during 1959, just seven years after the gardens first opened to the public. Each of the train's three cars appears "filled to the gills" with happy parents and children.

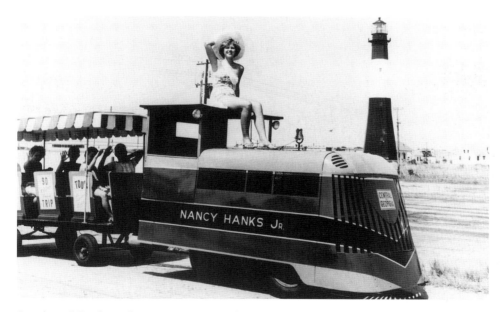

Say cheese! By the early 1960s, tourists could ride aboard a sightseeing "road train" on Tybee Island called the *Nancy Hanks Jr*. Here, a pretty model and a load of tourists pose with the train in front of the celebrated Tybee Light.

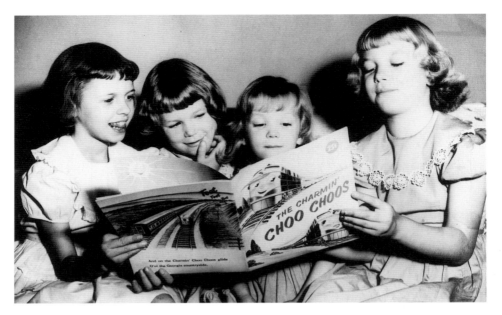

These four charming girls are reading about Central of Georgia's "Charmin' Choo Choos," streamliners *Man O' War* and *Nancy Hanks II*. The girls, who lived in Savannah, are, from left to right: Janice, Cecile, and Ann Burrell; and Theus Smith.

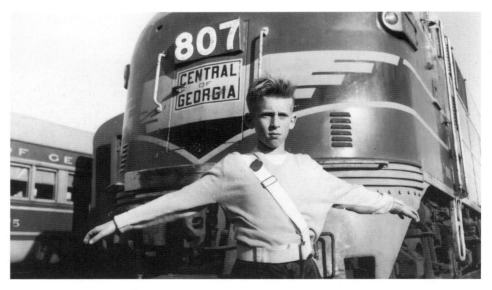

Thirteen-year-old Eugene Von Waldner of Savannah appeared on the cover of the February 1957 issue of *The Right Way*. Featured in the magazine's pages that month was the Railroad Safety Patrol, a new program which had recently been initiated by the railroad for school-age children. Modeled along the lines of school patrols which protected children from automobile traffic at street intersections, it was the responsibility of railroad safety patrolmen like Eugene to protect school children at railroad crossings along C of G lines as they walked to and from school.

three

At Work and
on the Job

The Men and Women
of the Central of Georgia

There's a lot more to running a railroad than just pulling the throttle and ringing the bell of a locomotive. The Central of Georgia employed dispatchers, track repair gangs, coach porters, machinists, freight agents, electricians, vice presidents, and even doctors, all of whom worked together as a team to keep the freight and passengers moving.

An important role of the company magazine through the years was to underscore this point to all of the railroad's employees. Through articles, locomotive engineers came to understand a little bit more about the daily lives of shop machinists, machinists became aware of the average workday of a coach porter, and so on.

In its own very important way, the *Central of Georgia Magazine* provided much more than just information. It created teamwork.

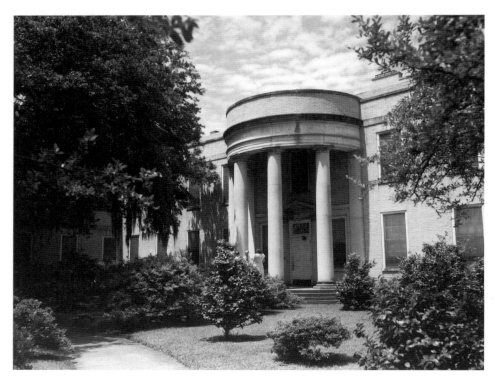

This beautiful structure is the Central of Georgia employee hospital on Bull Street in Savannah. It opened in July 1927 and for more than a quarter of a century provided care for Central employees using the latest in modern medicine technology. The hospital functioned very much like today's managed health care organizations; at the time that this photo appeared in a July 1952 article in the railroad's magazine, each worker contributed $3.25 per month to a company-administered fund in exchange for no-cost health care.

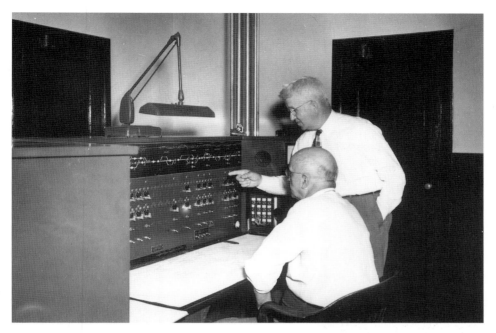

Dispatcher John T. Stark (seated) and chief dispatcher W.L. Chandler operate the CTC (Centralized Traffic Control) board at Central of Georgia's offices in Macon Terminal Station. When the technology was first developed in the 1930s, CTC boards allowed operators to throw switches within a several-mile radius. Now computerized CTC systems operate track covering thousands of miles.

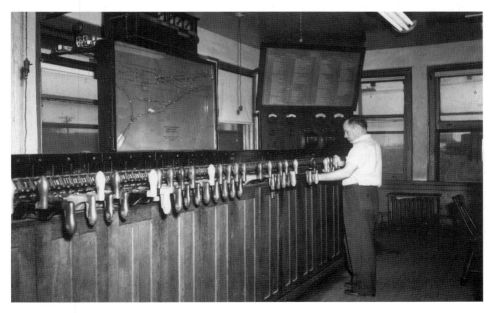

Central of Georgia operator E.C. Wilder manipulates the levers at Macon Junction in September 1948.

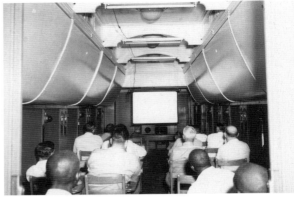

Above: Employee training was always at the top of the Central of Georgia's priority list. State-of-the-art training facilities, such as the instruction car "Progress," shown here at Cedartown, Georgia, August 1950, helped Central stay ahead of competitors and keep up efficiency. The "Progress" was formerly Pullman observation car "Monte Rosa"; it was converted to its new configuration by the railroad's Savannah passenger car shops.

Left: Before radio communication was commonplace, telephone booths like this one—along a Central of Georgia main line—were used by crews to communicate with dispatchers.

PBX operators S.S. McKinley and Alma Lavender wonder at the skill of their co-worker Miss McGill at the Central's offices in the Rhodes-Haverty Building in downtown Atlanta.

Above: Herbert Walton, a Central of Georgia telephone maintainer at Macon, Georgia, makes his daily check in February 1951, ensuring that Central phones in stations and along rights-of-way in his district are in working order.

Right: Here, Walton repairs a broken telephone line from a cable buggy, a contraption which was suspended from steel telephone cable and rolled along it via two flanged wheels. The harness Walton is wearing was a safety measure, affording him fall protection.

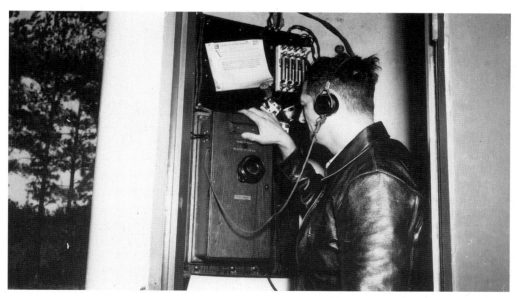

Once he found and repaired a problem in a telephone line, Walton still had to do a field check of all telephones affected to make sure his repair took. Many train orders were given by telephone, so they were of vital necessity to the railway.

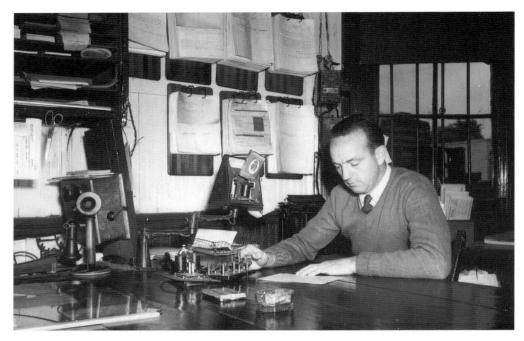

Agent W.C. McLaney of Chipley, Georgia, ran a tight ship, as is evidenced by the immaculate paperwork in his office. McLaney was all business as he worked the telegraph key in October 1950. Chipley became Pine Mountain that year.

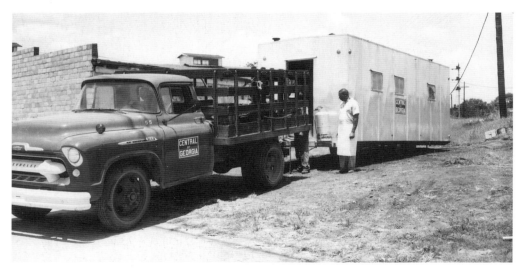

During 1956, the Central of Georgia began replacing the camp cars—railroad cars outfitted with primitive sleeping and cooking facilities—used for overnight lodging by its track repair gangs with RV-like highway vehicles. Calling the new vehicles "highway camp cars," the *Central of Georgia Magazine* pointed out that the road trailers could arrive at job sites far more quickly than their rail-bound predecessors. The trailers were pulled by heavy-duty Chevrolet trucks like this one, three at a time.

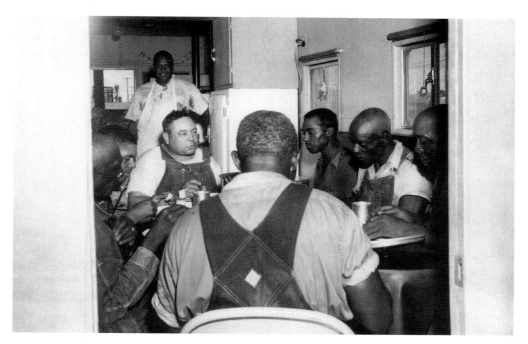

Above: White-aproned cook R. King proudly looks on as a track repair gang eats dinner aboard one of the C of G's highway camp cars in 1956. "Each gang has three cars," noted the company publication, "One for combination cooking, dining and recreation; one for housing the laborers; and one for the foreman."

Right: In another June 1956 view aboard one of the Central's highway camp cars, apprentice supervisor H.D. Mallard does paperwork at the desk located in the foreman's trailer. The Atlantic Beer pin-up calendar was discreetly left out when this photo ran in the October 1956 issue of the railroad's magazine.

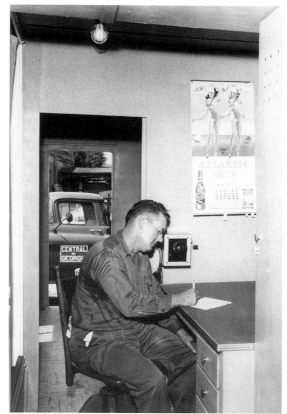

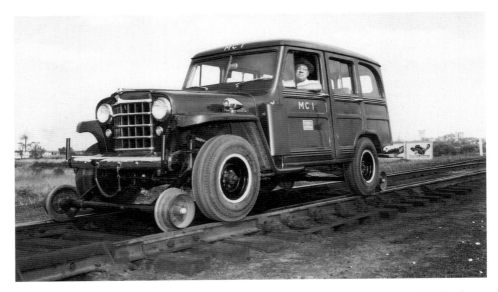

Central of Georgia MC 1 was acquired by the railroad in the 1950s. A Fairmont Hy-Rail vehicle built on a Willys Jeep Wagon frame, MC 1 was quite similar to other track inspection vehicles of this vintage. Hy-Rail vehicles like MC 1 could travel by either highway or rail for the purpose of inspecting track along railroad lines. This particular photograph was taken at Savannah Yard and appeared in the November 1952 issue of the *Central of Georgia Magazine*; that's track supervisor Walter Burke at the wheel of MC 1.

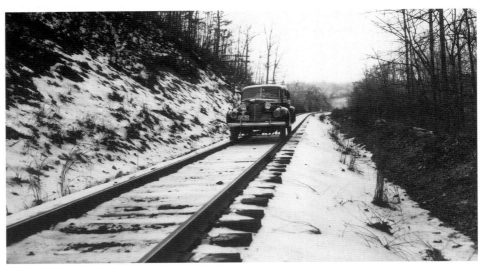

One of the C of G's track inspection vehicles, rail motor car C-60, was captured with fresh snow on the ground during a track inspection jaunt in February 1949 on the railroad's Chattanooga District. C-60, which was assigned to the railroad's Columbus Division, was different from the versatile Hy-Rail vehicles which appeared on the company's rosters in later years; after her Goodyear tires were replaced by steel flanged wheels in a modification, C-60 would be forever bound to the rails until her retirement.

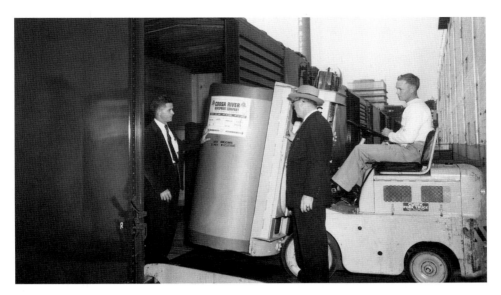

"New equipment keeps coming," boasted *The Right Way* magazine in the original caption for this photo. New steel boxcars—including this one, only one of 1,000 such cars built for the railroad by the Pullman-Standard Car Manufacturing Company—were big news on the Central of Georgia in 1953. Coosa River Newsprint employee C.H. Harkins loads newsprint, bound for New Orleans' famous daily, the *Times-Picayune*, aboard one of the new boxcars, while J.B. Norman of the Central and D.A. Jones of Coosa River Newsprint look on.

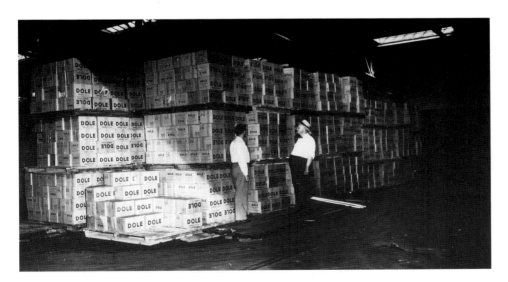

Pallets stacked high with cases of Dole pineapples rest in a warehouse at Savannah's Waterfront Terminals in August 1948. The pineapples—newly arrived from Hawaii—would soon be placed in refrigerated boxcars (known simply as "reefers") and sent by train to inland destinations in the Southeast on journeys which began on Central of Georgia rails.

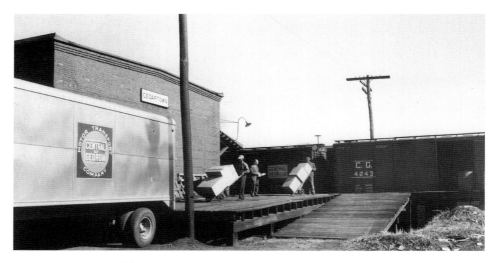

A pioneer in intermodal transportation in the Southeast, the Central of Georgia Railway Co. spawned the Central of Georgia Motor Transport Co. in January 1951 in order to make the shipping of smaller loads more efficient and consistent. Here, at Cedartown, only a few weeks after the inception of the Motor Transport Co., Central of Georgia employees transfer less-than-carload packages from boxcars to trucks prepared for speedy delivery.

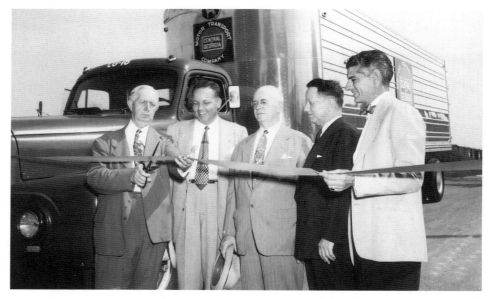

On July 14, 1952, Central of Georgia Motor Transport Company initiated four new truck routes within Georgia. Towns and cities served by the new routes included Statesboro, Metter, Midville, Augusta, Tennille, and Sylvania. In this photograph, which appeared in the August 1952 issue of the *Central of Georgia Magazine*, Augusta city councilman Frank Courtney cuts an inaugural ribbon as (from left to right) C of G officials Ray D. Massey and W.E. Stewart, along with the president of the Augusta Chamber of Commerce, Ray Campbell, look on.

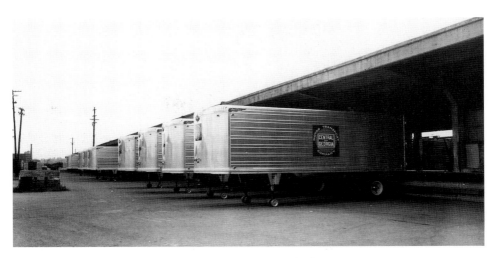

These Great Dane trailers were purchased by the Central of Georgia Motor Transport Company in 1951. By May of that year, the C of G's trucking subsidiary had seven international tractors and nine Great Dane trailers in operation in its coordinated rail-truck service. "All shipments are handled on railway bills of lading and at railway rates. Thus, the public is provided with the safeguards and advantages of railroad responsibility," noted the company magazine of the new service.

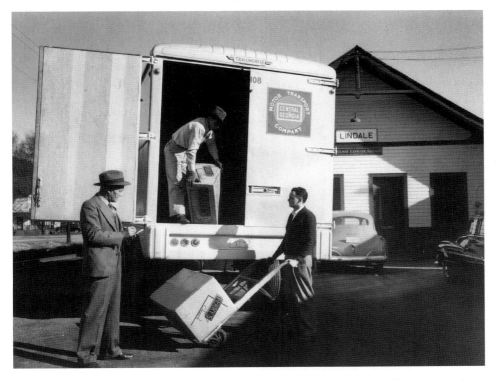

Less-than-carload packages are unloaded from a Central of Georgia Motor Transport truck in Lindale, Georgia, by C.G. Boone in 1951.

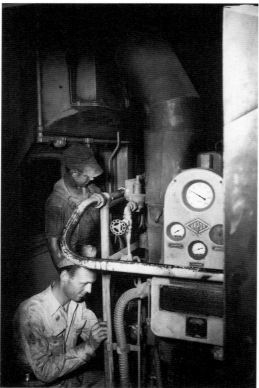

Above: A new repair garage for the Central of Georgia Motor Transport Company was big news in the September 1953 issue of the *Central of Georgia Magazine.* Located at 340 Hazel Street in Macon, the new shop repaired the growing fleet of trucks, trailers, buses, and Highway Post Offices operated by the pavement-bound subsidiary of the railroad. Here, G.L. Wait, C.E. Free, and I.L. Webb are shown in the garage, where Highway Post Office CG-201 was on the maintenance rack. The Central began replacing its branch line Railway Post Offices with Highway Post Offices like CG-201 during 1952; by 1953, some five of these vehicles were in operation.

Left: Pipefitter W.A. Chancellor (top) and electrician W.W. Phillips work on the steam generator of a diesel locomotive in the Macon, Georgia diesel shop, September 1948.

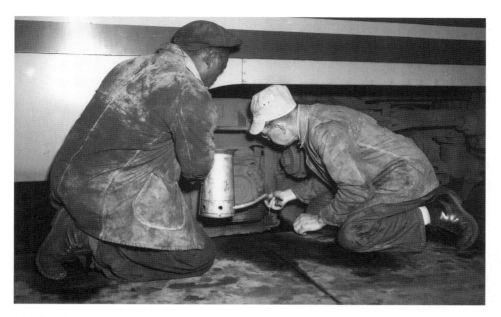

This knocker says that keeping it lubed is half the battle: the gentleman on the right, Central of Georgia lead car inspector B.F. Woodard, is kneeling beneath grille-lounge car 691 to lubricate and inspect its Hyatt roller bearings at Savannah's shop in March 1950. He is assisted by oiler William Braxton. Car inspectors on the Central and other railroads were familiarly known as "car knockers."

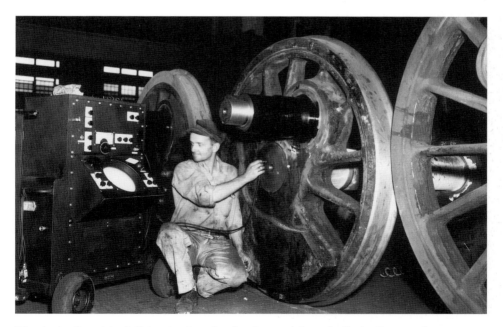

The device Roy Marshall is using here is a "stethoscope for safety"; the Sperry reflectoscope was used to detect hidden flaws or cracks in steam locomotive driving wheel axles. Marshall, a Central of Georgia shop inspector at Macon, uses the reflectoscope here in September 1950.

Left: Mr. Himes is here to help! Electrician H.E. Himes Jr. inspects the electrical locker of a coach on the *Nancy Hanks II* at Savannah in March 1950.

Below: Welded rail was beginning to replace joined track sections on the Central's main lines during the 1950s. Here, L.W. Schientinger, service engineer, with supplier Oxweld, along with Central of Georgia field welder Epps pay close attention to the process of welding two sections of rail together in October 1952. Field welds such as these could be made in a mere five minutes.

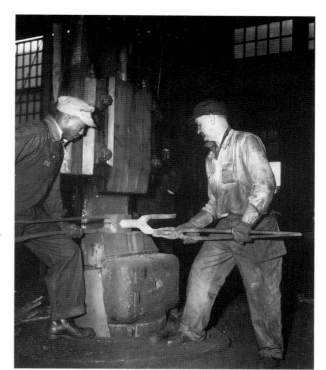

Right: Harden Key, J. Ellerson, and I.E. Taylor, Central of Georgia employees at the railroad's Columbus Shops, each are vital parts of the process of forging a steam locomotive eccentric crank in December 1948.

Below: R.G. Jefferson, general foreman at the Central of Georgia's Columbus Shops, inspects storehouse inventory in December 1948.

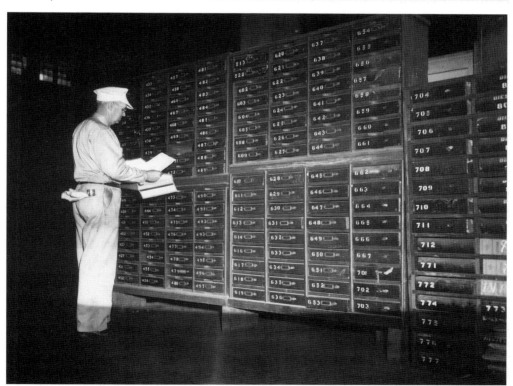

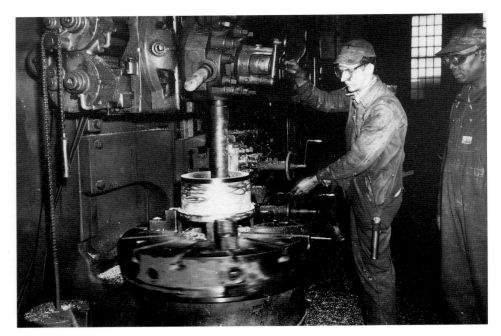

In a photo from the Central's Columbus Shops, machinist H.P. Ward and helper Albert Harris fabricate a steam locomotive part in December 1948. The image captures one of the realities of the lives of railroad shopmen and operating crews; through various means, African-American employees were effectively barred from the choice jobs on southeastern railroads during this era. For much of the 20th century—indeed, until the Civil Rights Movement of the early 1960s—blacks like Harris generally played secondary roles on railroads in the South; thus, holding a machinist's position was well beyond Harris's grasp when this photo was made.

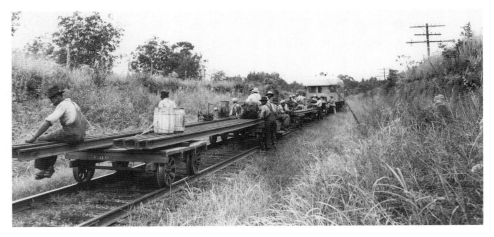

The Central of Georgia regularly employed a Sperry Rail Services test car to test rails along its lines for defects. These men are a part of a section gang that will replace defective sections of rail discovered by the contractor-operated test car, visible in the background at right, in September 1949.

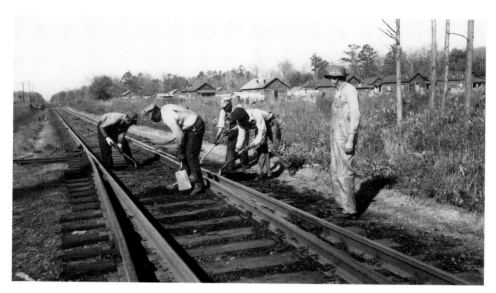

Once track is laid, but it is not free from maintenance. This crew in Munnerlyn, Georgia, led by section foreman U.N. Nasworthy, grooms the rails and ties in September 1949.

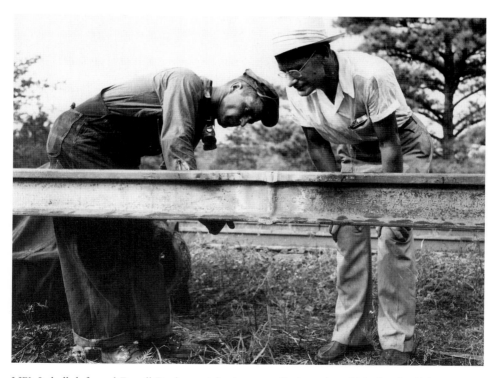

J.W. Isabell, left, and Ferrell Dodgen, right, inspect a fresh track weld in Leeds, Alabama, in October 1951. The Central of Georgia had just begun to replace bolted track sections with welded rail; the new track was more durable and safe, and gave a smoother ride.

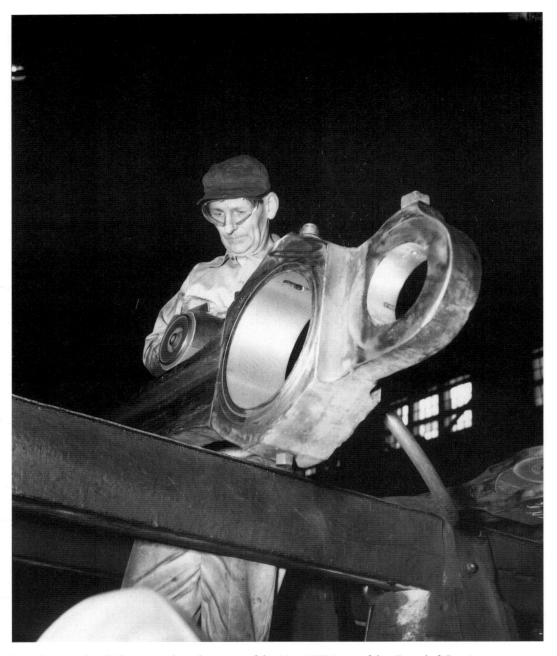

In a photograph which appeared on the cover of the May 1952 issue of the *Central of Georgia Magazine*, machinist George L. Bost polishes a steam locomotive side rod at C of G's Macon Shops. Bost had been at work with the Central since February 6, 1923, the magazine reported in a write-up about the picture, ". . . and all of his service [had] been in the Macon Shops."

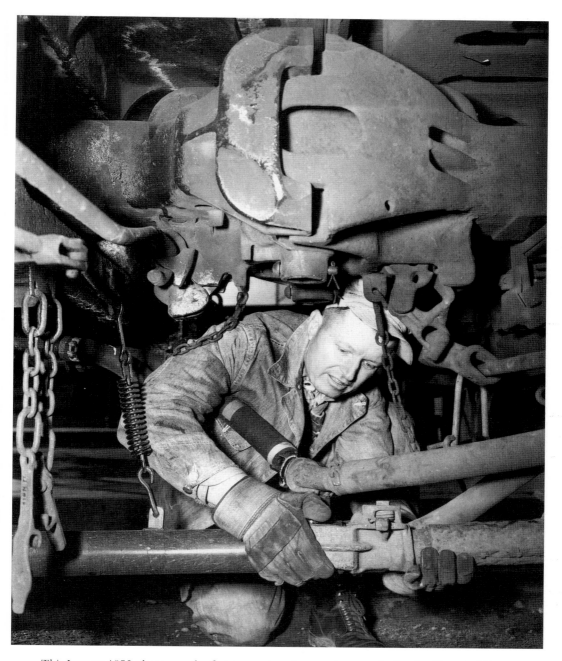

This January 1952 photo was the first in a series of cover photographs for the *Central of Georgia Magazine* entitled "Railroaders at Work." Carman H.H. "Blue" Burch of Columbus is shown connecting a steam heat line between two passenger coaches.

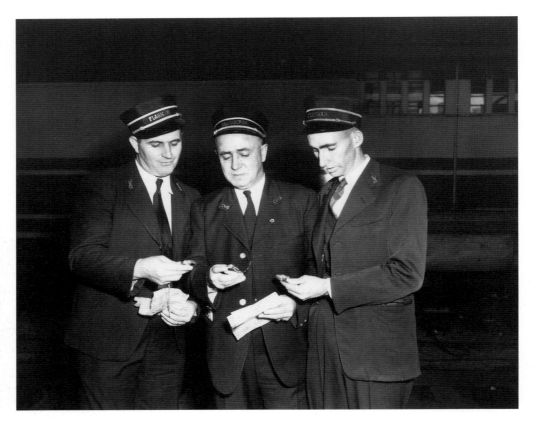

Before a passenger run, (left to right) flagman L.W. Parks, Conductor H.M. Watson, and flagman
W.T. Kendricks compare watches at Atlanta Terminal Station, October 1948.

four

All Places
Large and Small

Yards and Shops
of the Central

Atlanta Terminal Station was perhaps the grandest terminal at which the Central's trains called, but it was far from the only place. From tiny combination freight-and-passenger stations dotting C of G lines in Georgia and Alabama, to massive freight yards in Columbus and Savannah, there were many places that the railroad came to label as its "home turf."

Company photographers were quick to record goings-on at the Central's huge Waterfront Terminals in Savannah, for instance. This large ocean port served many types of ocean freighters, including those of Seatrain Lines, one of the early ship-to-rail intermodal carriers.

The C of G's repair shops at Macon and Savannah—and the locomotives and cars which these facilities maintained and rebuilt—were often documented, but editors of the *Central of Georgia Magazine* knew well what many modern railroad buffs too often forget: a railroad's facilities are as key to its operations as its trains.

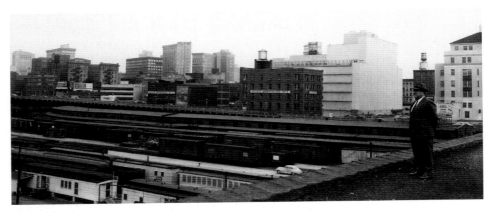

Above: Atlanta Terminal Station manager H.B. Siegel surveys the tracks heading into the great station, November 1949. The growing Atlanta skyline is prominent in the background of this photograph, while in the foreground an ancient combine—minus its trucks and other undercarriage equipment—and other vintage wooden passenger cars while away their declining years.

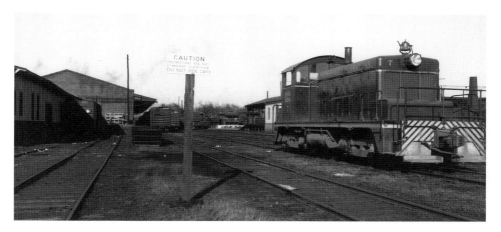

Shown in this January 1949 photo is the Central's Augusta, Georgia yard. A freight building— used for the loading and unloading of less-than-carload freight and express—is apparent at left in the scene, while an old boardinghouse molders in the distance beyond. That's diesel-electric switcher locomotive 7 up front, an SW1 model manufactured by the Electro-Motive Division of General Motors and delivered to the Central of Georgia in 1941. No. 7 boasted 600 horsepower.

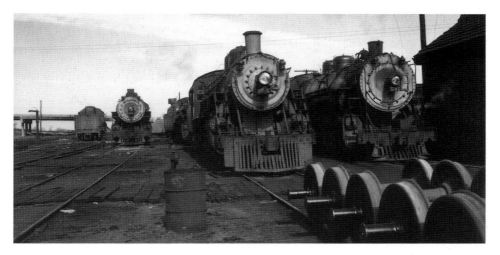

This scene at the Cedartown, Georgia, Central of Georgia yard in February 1949 reveals that the railroad's Griffin, Georgia-Chattanooga line was a bastion for steam locomotives in their twilight years. Included among those present are locomotive 635, a massive Lima Locomotive Works product originally delivered to the Illinois Central Railroad in 1916. At least two other massive Lima 2-8-2s are visible in this image, along with locomotive 417—a 4-6-2 built by Baldwin Locomotive Works and delivered to the Central in 1905.

Opposite below: "Office buildings are to Atlanta what furniture is to Grand Rapids and automobiles are to Detroit." So said Atlanta developer Charles Palmer in 1930—a fact which is confirmed by this August 1950 photo of the city, taken from Terminal Station. Central of Georgia's diesel-electric-powered *Nancy Hanks II* and C of G diesel-electric switcher 30—an S2 model built by Alco in 1944—frame the photograph.

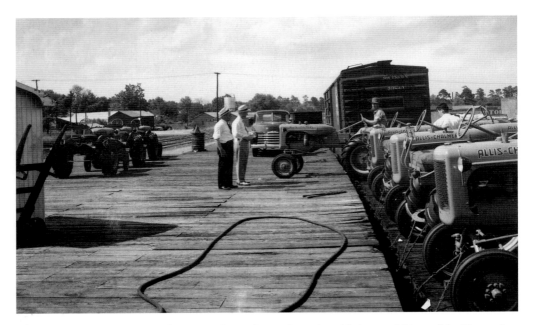

The Central gained access to the town of Statesboro, Georgia, with its acquisition of the Dover & Statesboro Railroad in 1901. Some 48 years later, in May 1949, a company photographer captured this scene on the platform of the railroad's freight station in the town, as a load of brand new Allis-Chalmers tractors—bound for a local agricultural implement dealer—were unloaded from a flat car.

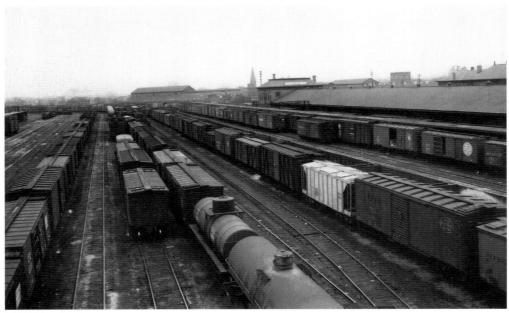

The Central of Georgia's yard at Columbus is laden with freight cars in this December 1948 view. Cars of many varieties are in evidence; all await switching onto freight trains for destinations in the Southeast and beyond.

The Central of Georgia's modern Macon Shops—shown here in photos made in 1950—was constructed in 1907, the same year in which noted financier E.H. Harriman gained control of the railroad for some $20 million. The complex was a vast improvement over the railroad's former main shop facility at Savannah, portions of which dated from before the Civil War, as well as its earlier Macon shops facility, which it inherited from a predecessor railroad. Macon Shops boasted a 22-stall roundhouse—which was served by a 100-foot turntable, capable of handling the Central's largest steam locomotives—and a locomotive backshop which could overhaul 25 steam engines at once.

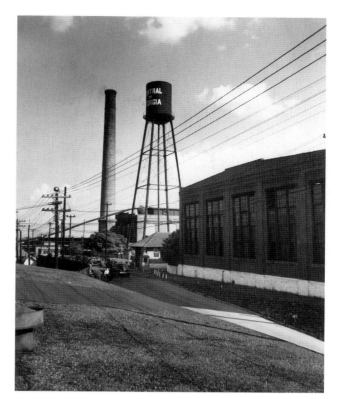

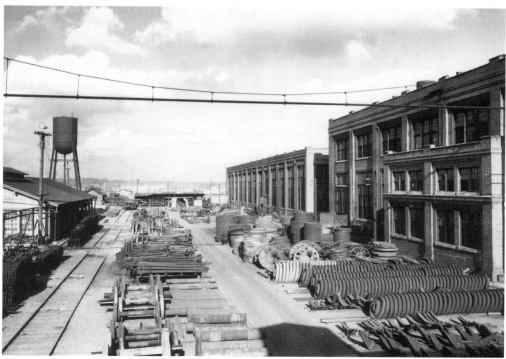

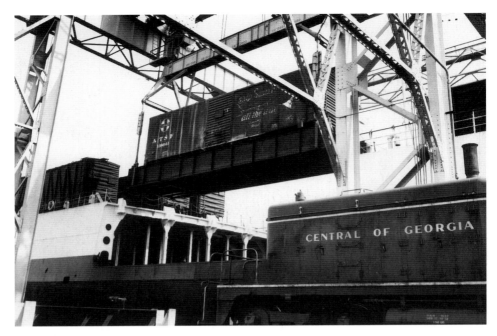

In the early 1950s, Seatrain Lines began offering twice-a-week service from two berths at the Central of Georgia's port facilities in Savannah to the Northern port of Edgewater, New Jersey. The ocean line specialized in transporting loaded railroad freight cars aboard specially designed ships and transporting them by sea from one coastal port to another. Here's how the service worked: Loaded boxcars were brought to a wharf by rail, hoisted aboard ship via massive cranes, and carried either north or south by sea. Once at its destination port, the ship unloaded its cargo of freight cars, which were then returned to the rails and sent to their ultimate destinations. The cooperative service between railroads and Seatrain proved quite popular with shippers, frequently saving them time and money when compared to an all-rail routing. These photos show the S.S. *Seatrain New York* being loaded at Savannah.

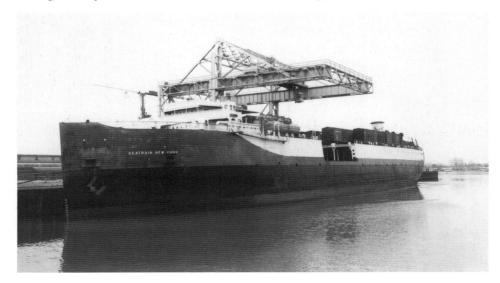

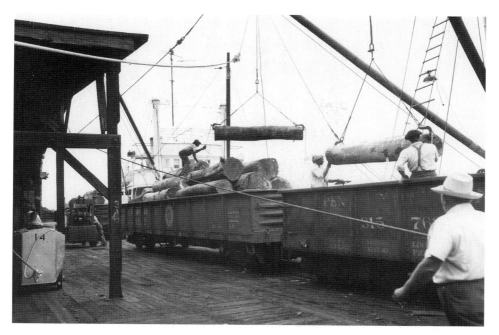

The Central purchased a large portion of land along Savannah's waterfront during the 1880s and developed it into Central of Georgia's Waterfront Terminals, shown here in August 1948. In this image, mahogany logs—perhaps from Cuba or Central America—are offloaded into gondola cars which will carry them to furniture and specialty wood products producers inland.

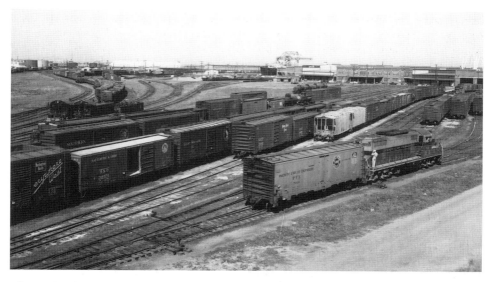

The yard at the Central of Georgia's Waterfront Terminals at Savannah is bustling in this mid-1950s view. Waterfront Terminals—located on the Savannah River north and west of downtown, near the Eugene Talmadge Bridge—was purchased by the Georgia Ports Authority in 1958. Though much of the facility was torn down and rebuilt by the Ports Authority, the site remains active today, and is operated as the Ports Authority's Ocean Terminal.

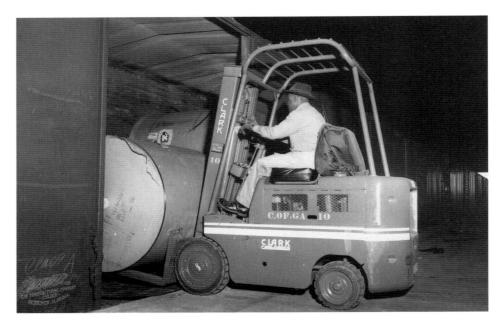

Of the many types of light cargo handling equipment used by the Central of Georgia, forklifts were perhaps the most versatile. The railroad ordered numerous fork trucks of three different load capacities for its freight stations so that it could handle all forms of less-than-carload freight with ease. The Waterfront Terminals at Savannah had a goodly number of them on its equipment roster, too; shown here is an expert operator loading a roll of paper into a C of G boxcar at the Terminals, *c.* 1955.

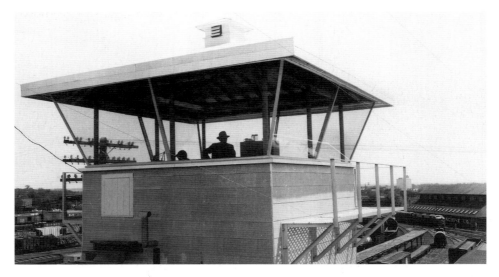

A new yardmaster's tower, completed in March 1957, was one of many improvements to the Central of Georgia's Columbus Yard. The glass-enclosed structure stood 60 feet high and incorporated an extensive speaker system for effective communication between the yardmaster and yard personnel.

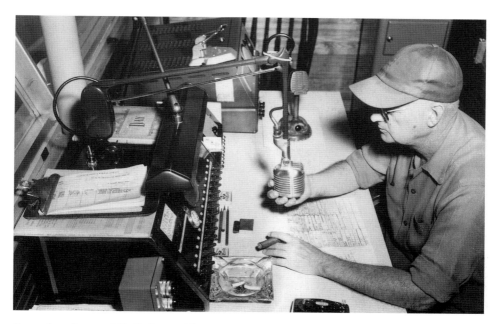

General yardmaster J.D. Bailey and his assistant, Mr. Davenport, were photographed in the newly finished tower at C of G's Columbus Yard in March 1957.

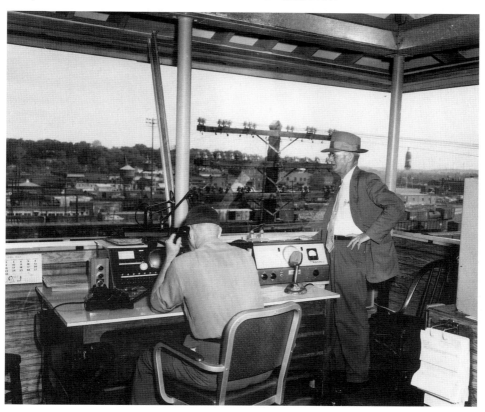

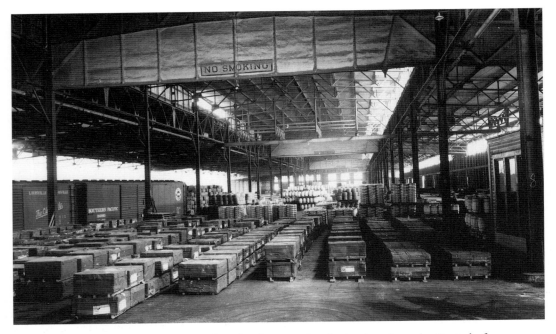

Shown here is cargo waiting to be distributed to its respective destinations from the Central of Georgia transit shed, Waterfront Terminals, Savannah, *c.* 1955.

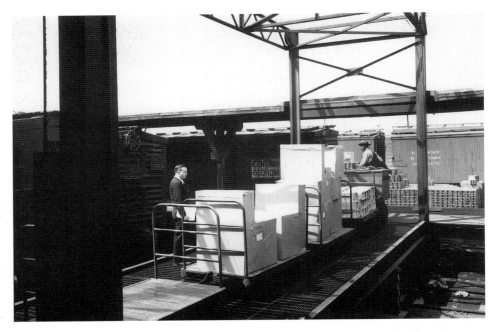

An employee at Central of Georgia's Atlanta freight warehouse prepares to load less–than–carload freight into boxcars. This shipment had recently unloaded from a Central of Georgia Motor Transport truck and would soon leave for its destination via a Central of Georgia line emanating from Atlanta.

Right: All we know is that you're about to cross a lot of tracks: this photo of an automatic crossing signal taken at Macon, Georgia, in 1951 has conflicting opinions as to how many tracks there are, but rest assured that this automated wonder would warn you if any rail traffic was on its way.

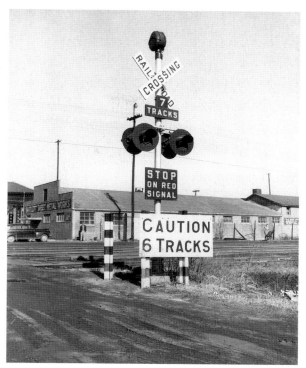

Below: This building at the corner of Louisville Road and Stiles Avenue in Savannah served as the headquarters of the Savannah & Atlanta Railway, beginning in 1924. The building had been constructed in 1916 by the Midland Railroad, another line controlled by the founder of the S&A, George M. Brinson.

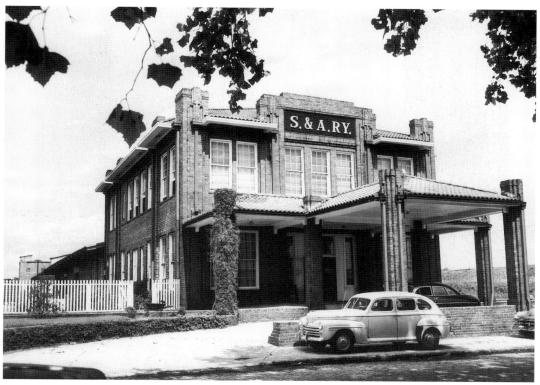

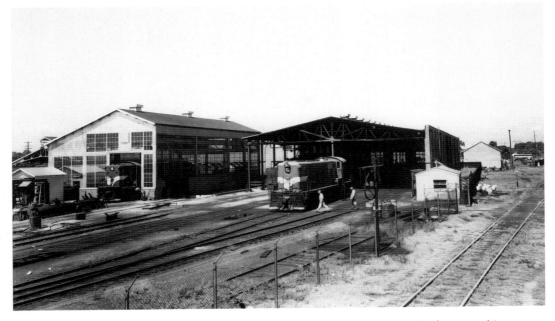

Shown here are the Savannah & Atlanta Railway shops at Savannah in 1951; in the foreground is the railroad's diesel shop, which was just one year old in this view. Central of Georgia subsidiary Empire Land Company had purchased the S&A from the Port Wentworth Corporation in that same year for $3.5 million.

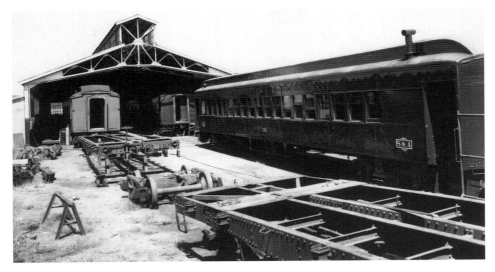

A Central of Georgia company photographer captured the entire passenger car fleet of subsidiary Savannah & Atlanta Railway at the S&A's shops in Savannah during 1951. The S&A owned a total of three combination coach-baggage cars for use in "mixed train" (passengers and freight) service between Savannah and Waynesboro, Georgia. Note the flue poking out of the roof of the car in the foreground; the combination cars were heated with pot-bellied stoves, holdovers from another era.

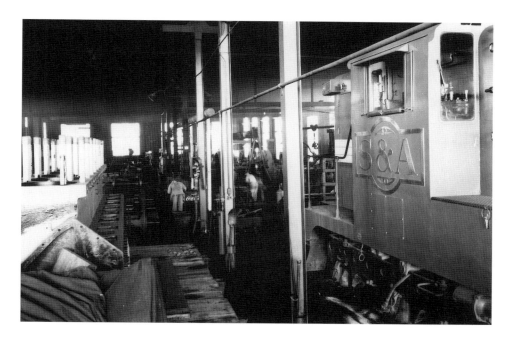

When the Central of Georgia acquired the Savannah & Atlanta Railway, it took control of S&A's 141-mile main line from Savannah to Camak Junction, 4,000 acres of land, 9 diesel locomotives, 5 steam locomotives, numerous boxcars, and a repair shop in Savannah (shown here).

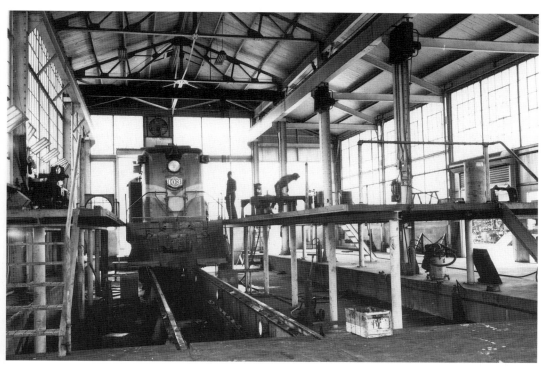

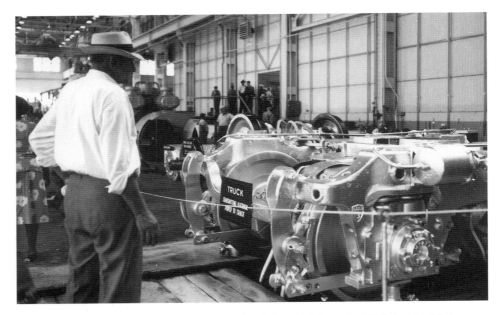

Central of Georgia completed an additional diesel shop in Macon in 1952 that doubled capacity and updated the repair facilities of its Macon Shops. This gentleman is looking at a set of rebuilt locomotive trucks displayed at the grand opening of the new facility.

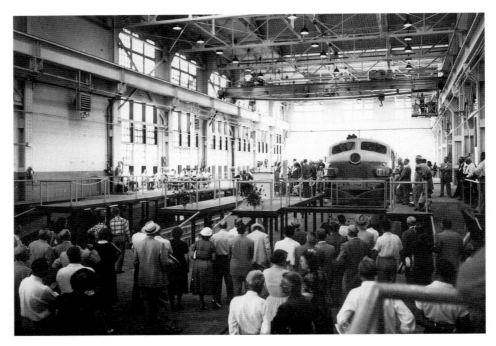

The crowd of people at the grand opening of the Central of Georgia's new Macon diesel shop listens to an address by the master of ceremonies, master mechanic H.M. McKay, in June 1952.

five

On the Rails

The Diverse Rolling Stock
of the Central
of Georgia Railway

Lest we forget: during the 1940s and 1950s the Central of Georgia did boast an impressive equipment roster, particularly for a railroad of its size, for it was during these years that behemoth 367,000 pound, J-3 class steam locomotives of the 2-10-2 wheel arrangement possessing 67,173 pounds of tractive effort shared the company roster with tiny 600 horsepower General Motors SW1 diesel-electric switch locomotives. And while the newest diesel-electric passenger locomotives available at the time—General Motors Electro-Motive Division E7s and E8s—could be found at the head of crack Central passenger trains like the *Nancy Hanks II* and the *Man O' War*, old steam engines like Central of Georgia no. 351, a 4-4-0 American-type built by the Baldwin Locomotive Works in 1891, still toiled in branch line freight service. The following pages contain photos of many examples of this diversity.

Happily, Central of Georgia rolling stock still exists, and not just in photographs. A 1907 Central of Georgia steam locomotive, C-3 class 2-8-0 no. 223, was rescued in May 1998 by the Historic Railroad Shops, an historic site created from the Central's old Savannah Shops and operated by the Coastal Heritage Society. It joins a Central of Georgia steam locomotive restored and already on display at the city's Savannah History Museum, located in the former Savannah passenger station where the *Nancy Hanks II* once called; the museum is also operated by the Society.

Still another old Central of Georgia steam engine, no 1501, a 4-4-0 built by the Baldwin Locomotive Works in 1881, is on display in Troy, Alabama, and former Central coaches are in operation in excursion service on tourist railroads in Tennessee, Georgia, and even Canada. And a steam locomotive and a number of cars are preserved at the Tennessee Valley Railroad Museum in Chattanooga.

These and other unrestored examples of C of G freight cars, passenger cars, and locomotives are still very much extant. They, like the photo files at the Atlanta History Center, create a fascinating window into the past of this proud little railroad.

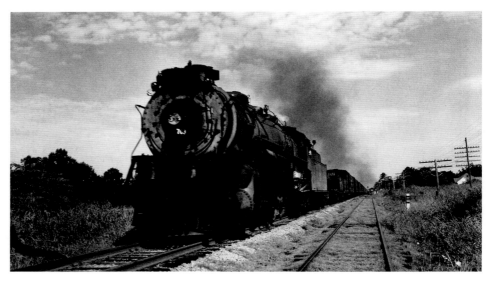

Birmingham District freight train no. 34, with Central of Georgia steam engine no. 703 leading the way, speeds along the tracks near Columbus, Georgia, on a beautiful August afternoon in 1949. No. 703, a locomotive of the 2-10-2 wheel arrangement, had been built for the Central by the Baldwin Locomotive Works in 1926. Its total tractive effort rating was 73,829 pounds.

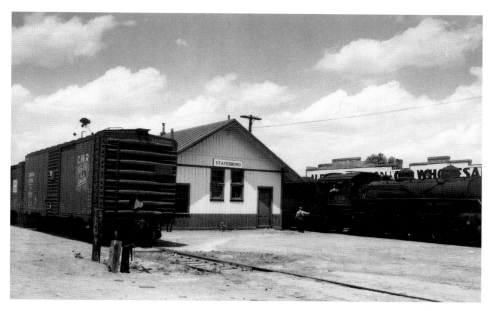

Central of Georgia 4–6–2 steam locomotive 439, built by the Baldwin Locomotive Works in 1913, sets cars out at the Statesboro, Georgia freight depot in May 1949. Venerable 439 was not long for the Central's roster when this photo was taken; she was retired less than three years later, in April 1952. A far-from-home Canadian National Railways boxcar sits on a track on the opposite of the depot from 439.

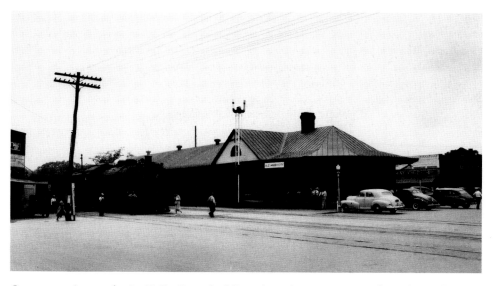

On a warm August day in 1949, Central of Georgia engine no. 654 sits idle at the sparkling clean station in Alexander City, Alabama. In the background the midday rush has hit Alexander City's A&P food market.

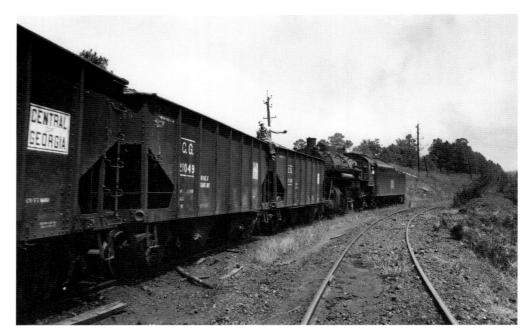

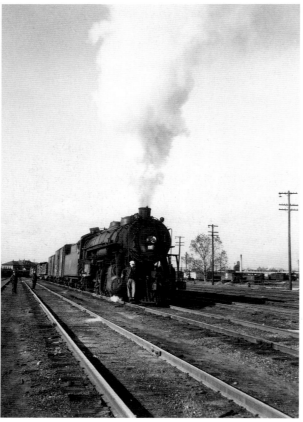

Above: At a Colgate, Alabama coal washing plant in September 1948, a Central of Georgia switch engine pushes a coal-filled freight train toward the washing facilities. The brakeman on top of the coal hoppers is giving the switch engine conductor the hand signal for "forward."

Left: Central of Georgia steam engine no. 777 prepares to leave the yard in Columbus, Georgia, in December 1948 carrying a load of pulpwood. Ready to throw a hand switch that lay just ahead, a switchman rides the footboard of the locomotive at the head of the train.

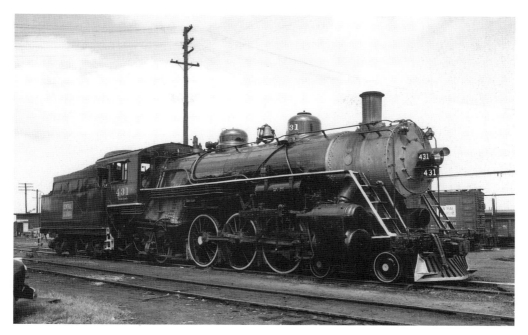

Pictured above is the Central of Georgia's Baldwin-built steam locomotive no. 431 in October 1949, just a few years before it was retired in 1952. This P-2 class Pacific-type passenger engine was constructed in 1912. It possessed 69-inch driving wheels and fielded a tractive effort rating of 36,500 pounds.

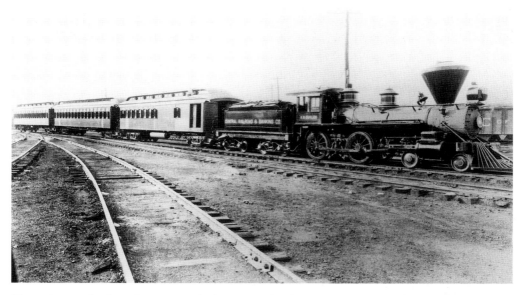

Shown here is the first of two Central of Georgia (then known as Central Railroad and Banking Co.) engines named *R.R. Cuyler*. This 4-4-0 American-type engine was built in 1854 by Rogers and was originally owned by the Memphis & Western Railroad. The *Cuyler* is shown here with three passenger cars, *c.* 1880. Its boiler was condemned in 1886.

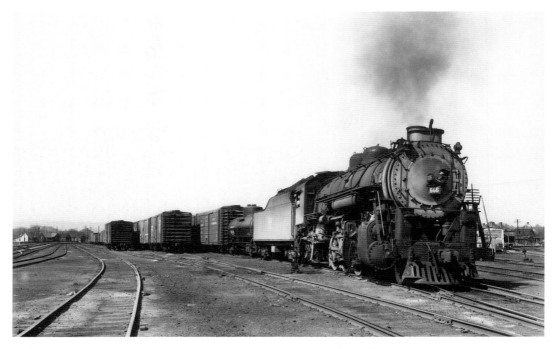

Apparently the Central of Georgia wasn't superstitious: here are shots of engine no. 666 at a stop and while pulling a load of freight through the countryside. The Central had nothing to fear, for the 666 lived the normal life of a locomotive; it was built in 1925 at Baldwin Locomotive Works and retired in April 1953.

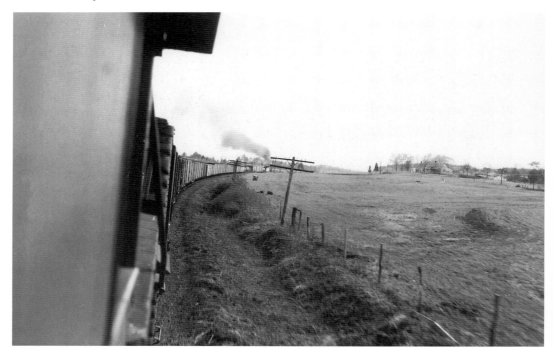

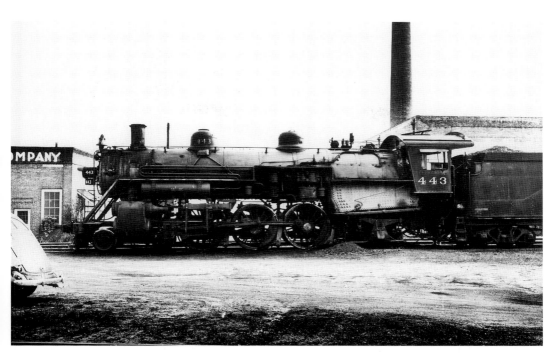

Central of Georgia's Lima–built locomotive no. 443 was photographed in October 1949. No. 443, a 4-6-2 Pacific-type passenger locomotive, was built in 1916; she was retired in May 1951.

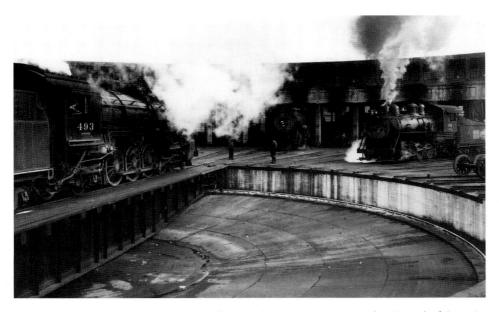

Engine no. 493, a 4-8-2 Mountain-type locomotive, prepares to enter the Central of Georgia roundhouse at Columbus in December 1948. Roundhouses, located at various points along Central's lines, were used for running maintenance of steam locomotives.

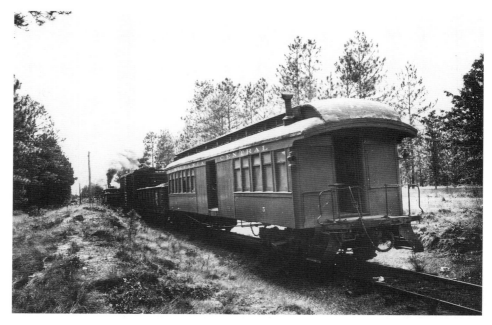

The Sylvania Central Railroad, whose engine and train is pictured here, had only one locomotive in 1947, a Baldwin 2-6-0 built in 1905. The line ran from Sylvania, Georgia, to Rocky Ford, Georgia, a distance of 15 miles, where it connected with the Central of Georgia. The line was abandoned in 1954.

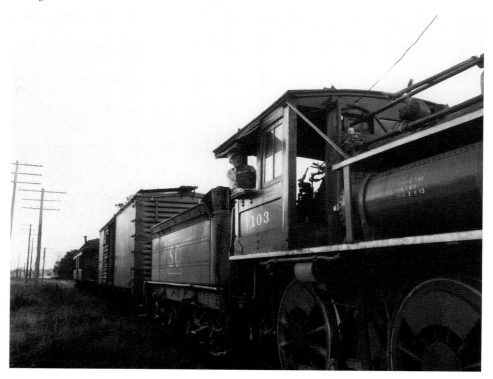

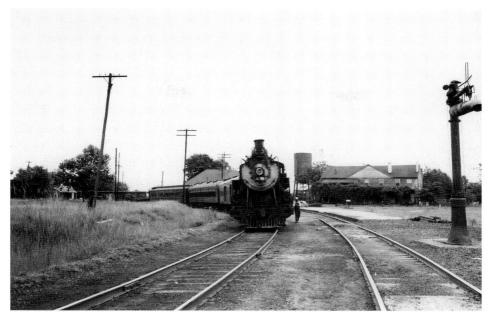

Central of Georgia passenger train no. 7 pulls three cars into the station at Union Springs, Alabama, in August 1949. No. 7's service began at Columbus, Georgia, and ran to Union Springs, where the train was split. One section went on to Montgomery, Alabama, while the other traveled to Andalusia, Alabama. The train is powered in this photo by steam locomotive 443, a 4-6-2 Pacific-type passenger locomotive which was delivered to the C of G by Lima in 1916. The engine was ultimately retired in May 1951.

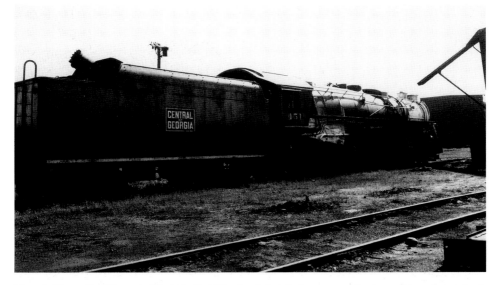

Here is Central of Georgia Lima-built "Big Apple" 4-8-4 steam engine no. 451 at the end of the line. No. 451 was built in 1943 and retired in 1953. The locomotive was held for possible display at Columbus until 1961, but was finally scrapped when these plans came to naught.

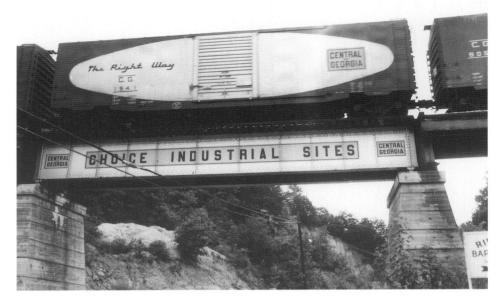

A new 50-foot boxcar and a brand-new highway underpass were featured in this 1955 photograph. The freight car is one of 500 built by Pullman-Standard's Bessemer, Alabama plant for the Central of Georgia Railway in 1954. The body of each of these cars was painted black with an aluminum oval design in its center; because of the distinctive shape of the design, these cars were often referred to as "football boxcars" in railroad vernacular. The underpass—located at Brumby, Georgia, near Chattanooga—replaced an earlier, narrower trestle and underpass which had been built by the Central in 1921 and spanned the town's McFarland Avenue.

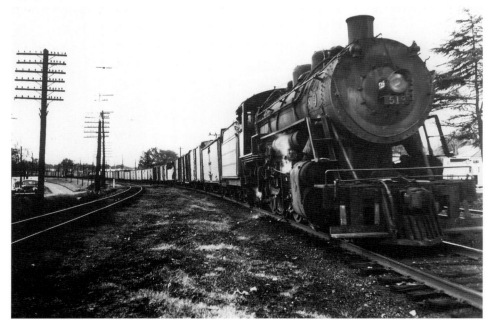

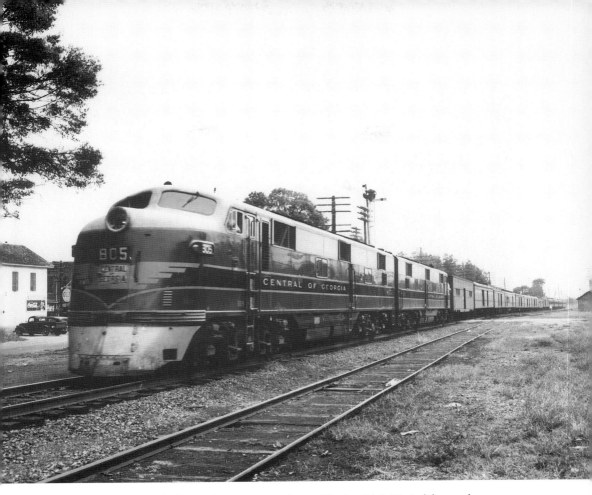

Above: Here the Central of Georgia passenger train no. 92, the *Dixie Limited*, leaves the station at Byron, Georgia, in September 1949. The diesel-powered train has just come from Macon's Terminal Station and is on its way to Americus and Albany. Two E7 locomotives headed-up the train this day.

Opposite below: Pictured above is a Central of Georgia freight locomotive no. 519, an MT class 2-8-0 built by Baldwin in 1907, pulling into Atlanta in November 1949. The engine was retired in May 1953.

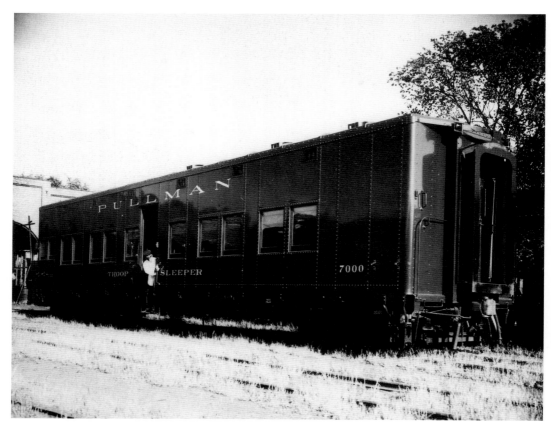

Above: Though not a true piece of Central of Georgia Railway rolling stock, this photo of Pullman troop sleeper 7000—photographed while in the C of G during WW II—underscores the important role that the railroad played in the war effort. With numerous military installations on or near its lines—from massive Fort Benning near Columbus, to humble Fort Screven near Savannah—the Central played a key role in transporting military personnel and supplies along the company's lines during the war. The Pullman Company built and staffed hundreds of sleeping cars like this one to carry troops during the war; so as to expedite their production, the cars were fashioned of a simple but heavily modified boxcar design.

Opposite below: A string of Burlington Refrigerator Express refrigerated and ventilated boxcars rolls along Central of Georgia tracks, *c.* 1950.

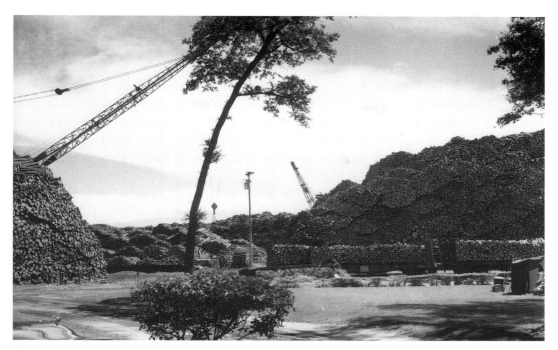

The Central of Georgia connected in Dothan, Alabama, with the Atlanta & St. Andrews Bay Railway, which is also known as the Bay Line. The two railway companies acted in cooperation to transport freight to ports and industries on the Gulf of Mexico via Dothan. Here a load of pulpwood is unloaded from Central cars at the International Paper Co. plant in Panama City, Florida, c. 1952.

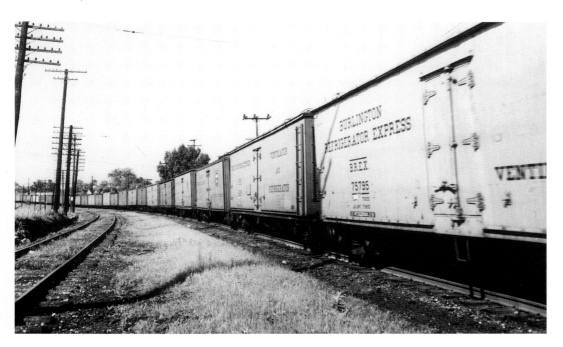

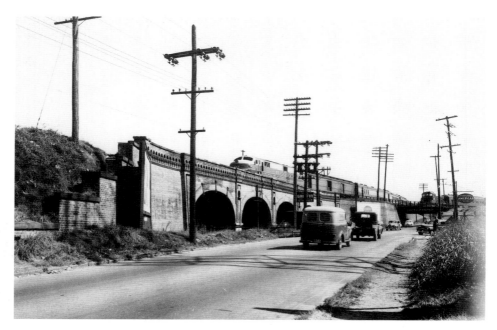

Ask Savannahians about the Central of Georgia Railway, and this fine structure is sure to come up in the conversation. It is the arched bridge over the Ogeechee Canal, at the intersection of the West Boundary Street and Louisville Road, near the railroad's passenger station. Here a Central passenger train led by E-unit 807 passes over the bridge in 1952, one hundred years after the completion of the brick monolith designed by the engineering firm of Mueller & Schwab. The arches remain a Savannah landmark to this day, and inspired the arch design on the Colonial Williamsburg Parkway in Virginia.

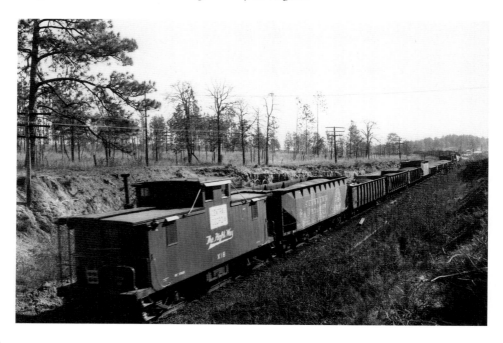

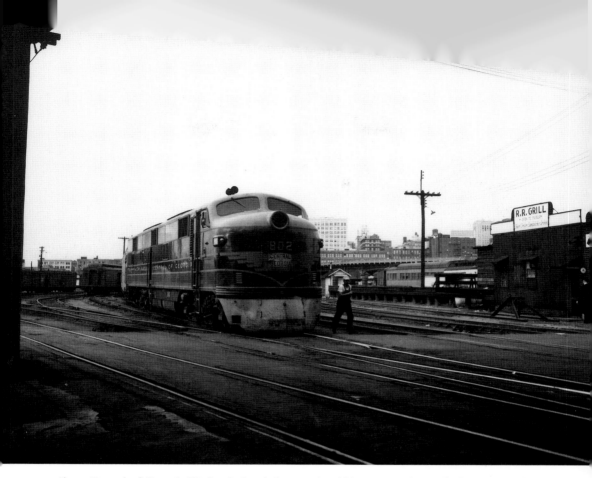

Above: Central of Georgia E7 diesel-electric locomotive 802 pauses in the yard adjacent to Atlanta's Terminal Station in July 1949. The Hotel Robert Fulton and other downtown landmarks are visible beyond the railroad yard, while railroad employees seem to be scurrying to a landmark of a different sort: the nearby R.R. Grill, which was ready to serve short orders, sandwiches, and drinks to hungry railroad employees and the public alike.

Opposite below: Central of Georgia wooden caboose X18 brings up the rear of a mixed freight at an unidentified location during the mid-1950s. Note the Seaboard Air Line Railroad hopper car just ahead of X18 with that company's large "through the heart of the South" logo on its flanks.

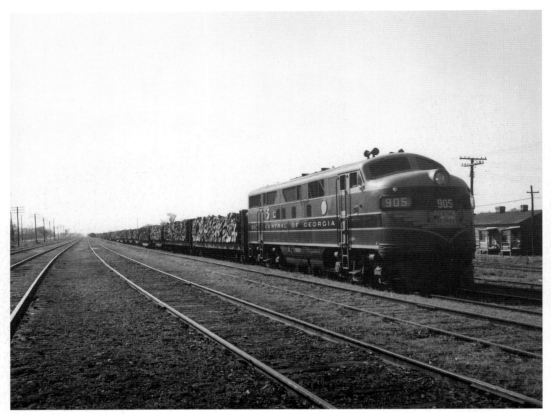

Pulpwood—used for making paper—frequently traveled from the logging operations of Georgia's pine forests to paper mills around the South via Central freights in cars called "pulpwood racks." At Savannah's West Yard in March 1950, F3 diesel–electric locomotive 905—a 1948 product of the Electro–Motive Division of General Motors—had over a dozen such cars safely in tow.

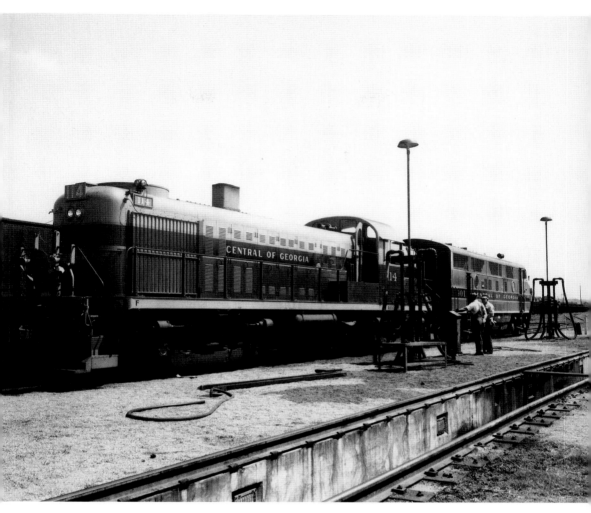

Central of Georgia no. 114, a 1600-horsepower RS-3 diesel-electric locomotive built by Alco in 1951, and no. 901, an F3 built by the Electro-Motive Division of General Motors in 1947, are shown on a fueling track at a yard on the Central of Georgia system.

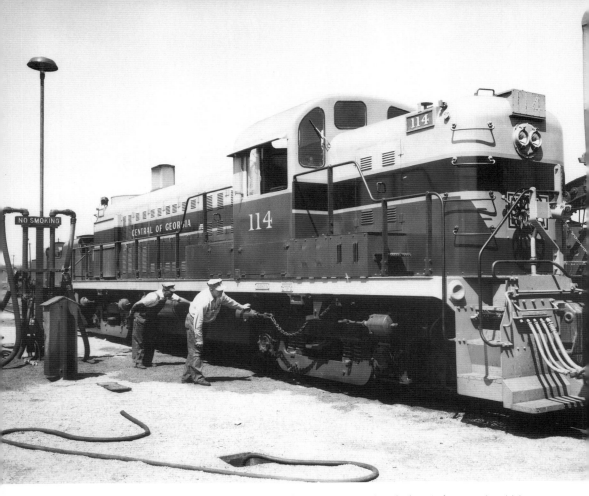

A locomotive inspector and a fueler give Central of Georgia RS-3 diesel-electric locomotive 114 a thorough once-over. All of the railroad's locomotives received a cursory mechanical inspection when fueled. The C of G had gradually replaced its steam locomotives with engines like no. 114—built by Alco in 1951—since putting its first diesel into service in August 1939. The railroad's last steam locomotive was replaced by a diesel-electric in May 1953.

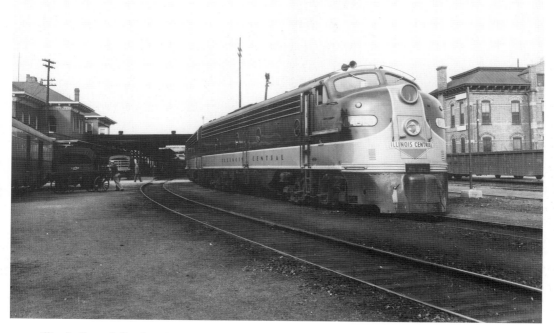

Illinois Central diesel engine no. 4026 on the *Seminole* passenger train, which ran from Chicago to Miami. The *Seminole* was operated jointly by the Illinois Central, the Central of Georgia, and the Atlantic Coast Line. This photo, taken perhaps in the Columbus passenger station, dates from the 1950s.

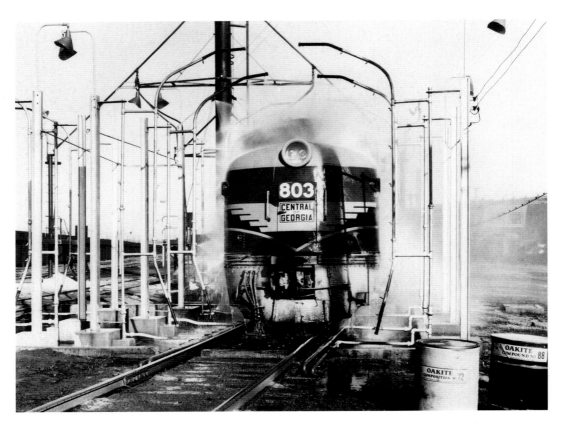

The locomotive washer at Macon could wash locomotives on either of two tracks. E7 diesel-electric locomotive no. 803, frequently used to power the *Nancy Hanks II*, here receives a regular cleaning in 1956.

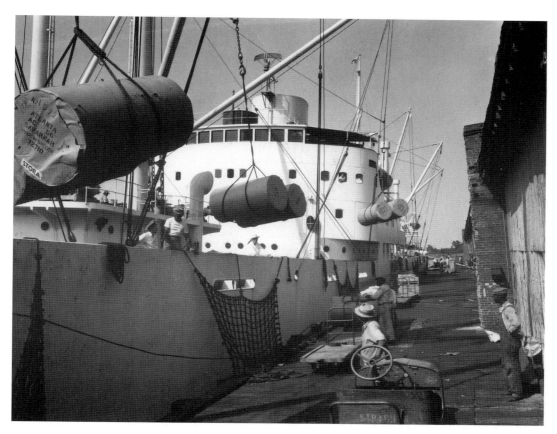

At the Ocean Steamship Company building at the Central of Georgia's Waterfront Terminals in Savannah, a roll of newsprint manufactured in Sweden is off-loaded from a seagoing freighter by a cargo crane in August 1948. The rolls of newsprint were destined for Atlanta and her dailies, *The Atlanta Journal* and *The Atlanta Constitution*.

At the Central of Georgia's Waterfront Terminals in Savannah, sulfate of ammonia is loaded into boxcars in March 1950.

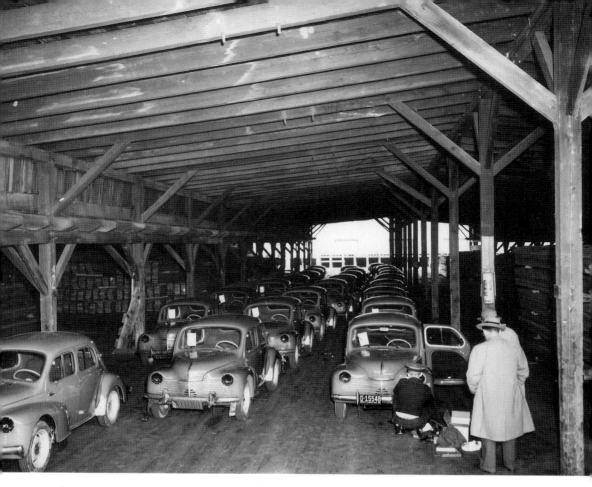

Autos were sometimes handled by the Waterfront Terminals. Dozens of Renaults arrived at the Savannah port from the French automaker in March 1950. While many of these cars would soon head to dealers via rail, the car receiving attention at right may have set out for its final destination by highway, as it has just received North Carolina plates.

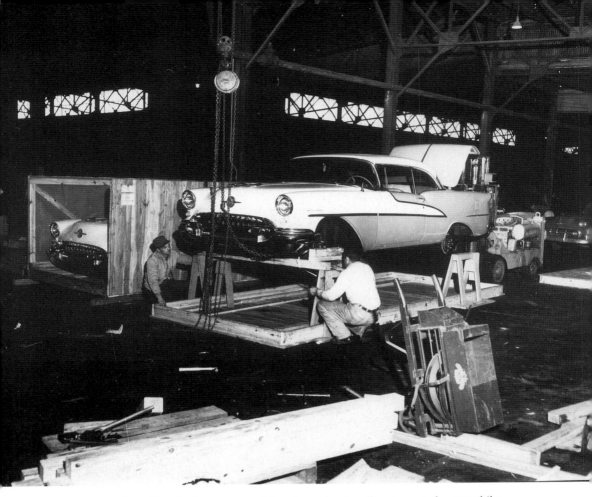

Savannah's Waterfront Terminals were not solely relegated to handling imported automobiles, however. In December 1954, brand new Oldsmobiles—along with a number of Buicks and Chevrolets— were crated up by employees of the port for export shipment to Brazil. The sleek two-door models were transported to the Latin American nation by the freighter *Santos*.

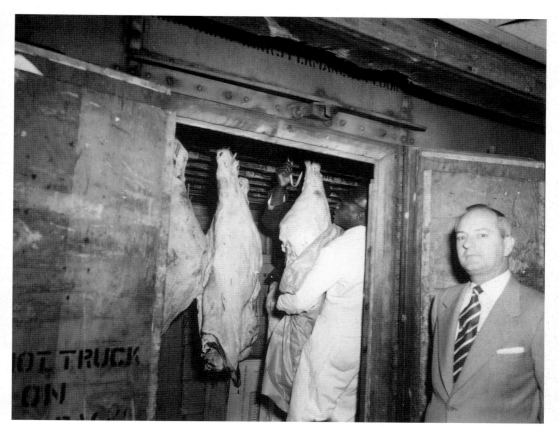

The warehouse of Savannah wholesale grocer H. Traub's Sons, Inc. served as a backdrop for this photo, which appeared in the April 1957 issue of *The Right Way*, Central of Georgia's company magazine. The picture was taken to accompany an article which celebrated the 50th anniversary of the 1907 Pure Food and Drug Act. Here, a Central of Georgia freight agent poses with a refrigerated boxcar containing sides of beef, while two H. Traub's Sons employees work to unload the car.

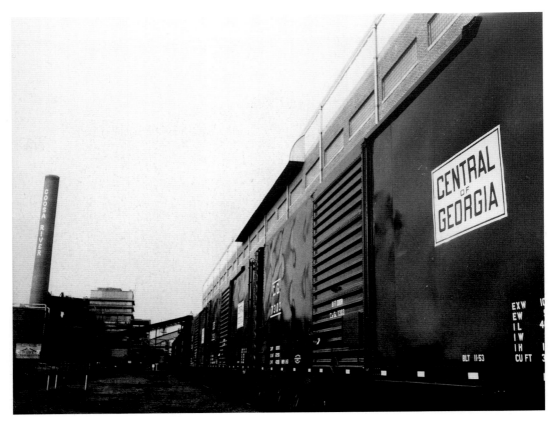

The Coosa River Newsprint Company plant in Coosa Pines, Alabama, served as the backdrop for this photo of gleaming new all-steel boxcars. The freight cars were built for the Central of Georgia by the Pullman-Standard Car Manufacturing Company at its plant in Bessemer, Alabama, in 1953.

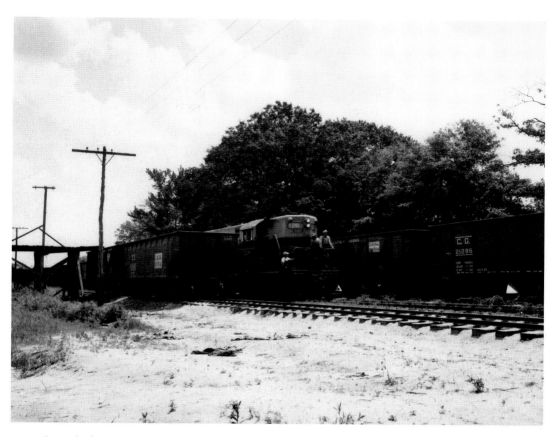

Central of Georgia diesel-electric locomotive no. 128, shown here switching hopper cars at a Colgate, Alabama coal washing plant, was built for versatility. A 1,500-horsepower GP7 manufactured by the Electro-Motive Division of General Motors in 1951, no. 128 was as comfortable handling switching duties at yards like this one as it was heading-up local freights.

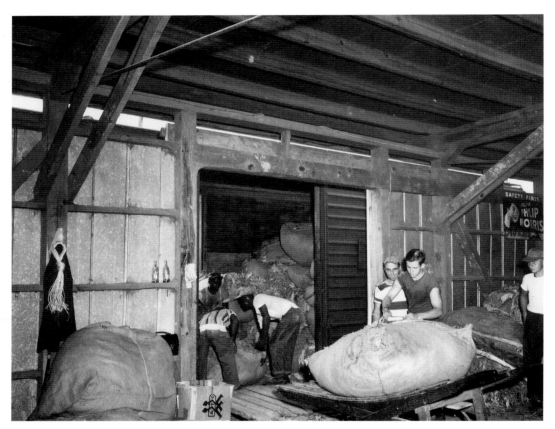

Bags of tobacco are loaded into a Central of Georgia boxcar from a warehouse at Statesboro, Georgia. C of G lines served numerous tobacco warehouses in the geographic region known as the Flue-Cured Tobacco Belt, which encompassed Georgia and Florida. Note the Philip Morris Tobacco sign in the background, exhorting workers to think of "Safety First!"

Acknowledgments

This glimpse back at the history of the Central would not have been possible without the help of some very special people. A large group of folks from the Atlanta History Center staff are owed much of this credit. Foremost among them is staff photographer Bill Hull, who spent countless hours copying the photos which appear on these pages. Thanks, Bill.

We'd also like to thank Atlanta History Center Executive Director Rick Beard and Anne Salter, director of the Center's library/archives, each of whom supported this project from the beginning. The same goes for Kim Blass, the Center's editorial director, who spent a great deal of time reading and re-reading these pages. And former Swan House Administrator Bill Bomar graciously agreed to review an early draft of this work, as well.

Credit is also due to Bill Schafer and George Eichelberger of Norfolk Southern who— even in the midst of their company's acquisition of much of Conrail—still found time to comment upon the text of this book. And earlier, Mary Civille and Connie Woods of *The Atlanta Journal-Constitution* made the photo of the last run of the *Nancy Hanks II* available to us for this work.

Finally, we'd be remiss not to thank Franklin M. Garrett, longtime historian of the Atlanta History Center. Mr. Garrett's writings about and enthusiasm for Atlanta and her railroads have not gone unnoticed by the authors. Indeed, they have been a true inspiration to more than one of us.

Resources and Selected Readings

Thousands of fascinating and moving stories behind scenes such as these tell the history of railroads in Atlanta and the Southeast. The Atlanta Historical Society, founded in 1926, shares these stories through exhibitions, programs, and collections at the Atlanta History Center, featuring the Atlanta History Museum, *c.* 1845 Tullie Smith Farm, the 1928 Swan House, 33 acres of gardens, and the library/archives. For more information on the scenes in this book or to order reproductions of these images, contact the Atlanta History Center. For further reading on the Central of Georgia Railway, consult the sources below:

Ambrose, Andy, and Darlene R. Roth. *Metropolitan Frontiers: A Short History of Atlanta*. Atlanta: Longstreet Press, 1996.

Beckum, W. Forrest Jr. and Albert M. Langley Jr. *Central of Georgia Railway Album*. North Augusta, S.C.: Union Station Publishing, 1986.

Beebe, Lucius, with C.M. Clegg. *Mixed Train Daily*. New York: E.P. Dutton & Company, 1947.

Davis, Burke. *The Southern Railway: Road of the Innovators*. Chapel Hill: The University of North Carolina Press, 1985.

Edmonson, Harold. *Journey to Amtrak: The Year History Rode the Passenger Train*. Milwaukee: Kalmbach Publishing, 1972.

Eichelberger, George, ed. *Central of Georgia Railway Passenger Equipment Diagram Book*. Atlanta: Southern Railway Historical Association, 1995.

Issues of *The Atlanta Constitution*.

Issues of *The Atlanta Journal*.

Issues of the *Central of Georgia Magazine*.

Issues of *The Official Guide of the Railways*.

Issues of *The Right Way* magazine (Central of Georgia Railway).

Issues of *The Right Way*, the newsletter of the Central of Georgia Railway Historical Society.

Issues of *Ties* magazine (Southern Railway).

Leuthner, Stuart. *The Railroaders*. New York: Random House, 1983.

Prince, Richard E. *Central of Georgia Railway and Connecting Lines*. Millard, Neb.: Richard E. Prince, 1976.

Schafer, Mike. *All Aboard Amtrak*. Piscataway, N.J.: Railpace Company, 1991.

Southern Railway Historical Association, "1997 SRHA Convention," *Ties: The Southern Railway Historical Association Magazine*, September–October 1997.